Cumberland
Valley

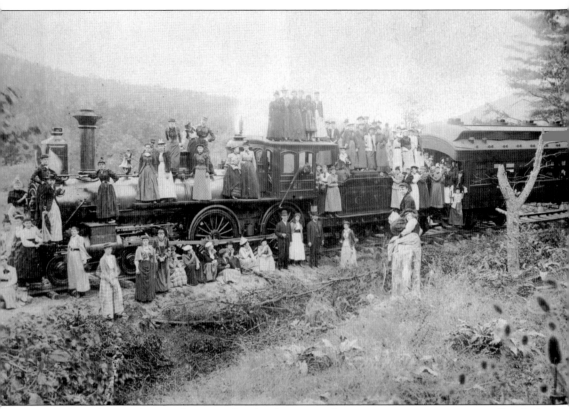

Students from Wilson College in Chambersburg are taken on an excursion to Mont Alto Park in 1891. The locomotive is "old No. 22" of the Cumberland Valley Railroad. Mont Alto Park was opened in 1875 by Col. George Wiestling, owner of Mont Alto Iron Works. (Courtesy of Franklin County Historical Society–Kittochtinny.)

ON THE FRONT COVER: This photograph was taken during the Old Home Week and Mercersburg College Reunion celebrations in 1912. The banner reads 1865–1880 and is further identified on the back of the postcard as "Apple-Higbee Reunion Decoration." Elnathan Higbee and Thomas Apple had both been professors at the college. The reunion was 150 strong and was made up of members of the classes of 1865 through 1880, a period known as the Apple-Higbee regime. (Courtesy of Franklin County Historical Society–Kittochtinny.)

ON THE BACK COVER: The Pioneer was a light passenger locomotive built for the Cumberland Valley Railroad and was strong enough to pull three or four cars at 40 miles per hour. It served the passenger service from 1851 to 1876 and was then employed until 1890 in the construction service. (Courtesy of Franklin County Historical Society–Kittochtinny.)

POSTCARD HISTORY SERIES

Cumberland Valley

From Tuscarora to Chambersburg to Blue Ridge

Ann Hull with the Franklin County Historical Society–Kittochtinny

ARCADIA
PUBLISHING

Published by Arcadia Publishing
Charleston, South Carolina

Printed in the United States of America

Library of Congress Control Number: 2010937245

For all general information contact Arcadia Publishing at:
Telephone 843-853-2070
Fax 843-853-0044
E-mail sales@arcadiapublishing.com
For customer service and orders:
Toll-Free 1-888-313-2665

Visit us on the Internet at www.arcadiapublishing.com

To the women in my life who inspired my passion for history: my mother, Martha, and my aunt, Elizabeth

CONTENTS

ACKNOWLEDGMENTS

The Franklin County Historical Society was founded in 1898 and since then its mission has been to promote and preserve local history. Many dedicated volunteer historians have spent countless hours working on its behalf to fulfill this undertaking. The collections of documents and archival materials in the society that were methodically researched by those historians have made my task much easier.

We owe so much to Murray Kauffman, foremost historian and one-man army, who not only saved our building from the wrecking ball, but spent his life investigating all facets of local history, creating a wonderful legacy for the future. A map he sketched of the early forts in the Cumberland Valley can be found on page 10.

I wish to thank Dr. Joan Applegate, who thoughtfully and painstakingly provided yeoman's service proofreading my writing so that it would be much more appealing to the audience. My assistant Ingrid Winckler spent hours on the details of the technical problems, and I appreciate her many creative ideas. I am grateful to my editor, Erin Vosgien, for her patience in answering my questions and for her specific knowledge on numerous issues related to this book.

Unless otherwise noted, all images are from the collection of the Franklin County Historical Society–Kittochtinny.

INTRODUCTION

The beautiful area lying between the Susquehanna and Potomac Rivers is known as the Cumberland Valley. That particular expanse between the Tuscarora Mountains to the northwest and the Blue Ridge Mountains to the south is the Lower Cumberland Valley. In between are minor mountain valleys such as Path Valley, Horse Valley, Amberson Valley, Bear Valley, and Cove Gap, through which wagoners crossed the mountains on their way west. These valleys were the drawing card as droves of early settlers found their way here on their quest for a better life.

The Franklin County portion of the Cumberland Valley was originally founded by Scotch-Irish pioneers; they were followed by German settlers. Both groups brought their cultures from the old country. As they pushed westward, particularly the aggressive Scotch-Irish, they tended to settle near water sources, founding early settlements with names like Rocky Spring, Falling Spring, Moss Spring, and Middle Spring. Extant documents show that they were issued the promissory land deeds known as Blunston Licenses as early as 1734. Around these springs, communities developed with a religious institution at their center. First were the Scotch-Irish with Presbyterian churches. Then the Germans founded both Lutheran and Reformed churches, and the Welsh brought the Baptist denomination. The Methodists, Mennonites, and the United Brethren arrived in the valley a short time later.

Next to religion, education was a core concern of these early settlements. Private schools existed as early as the 1770s, as indicated by a poem preserved in the Franklin County Historical Society archives. The poem was written by a teacher at Back Creek Schoolhouse in 1780. The Chambersburg Academy was founded as early as the 1790s as a grammar school and became a permanent seat of learning. In the succeeding century, further institutions of learning were connected to religious denominations—Mercersburg Academy (originally Marshall College) was associated with the Reformed Church and Wilson College with its Presbyterian association.

The 19th century ushered in an organized county government with officials, politicians, newspapers, medicine, and such transportation improvements as turnpikes, bridges, and railroads. One of the earliest industries in the county was iron smelting, as attested to by Carrick Furnace, Richmond Furnace, and Mt. Pleasant Furnace in Path Valley; the Mont Alto Iron Works in South Mountain; and Thaddeus Stevens's Caledonia Iron Works in the mountains toward Gettysburg. Some historians have suggested that Stevens, an ardent abolitionist, was motivated to keep his iron business afloat in the midst of enormous debt just so he could continue to use it as a cover for fugitives moving north on the Underground Railroad. Communities grew up around these furnaces, including a free black community near Caledonia Works that was known to have sheltered runaway slaves.

Agriculture was, as it is today, the most important industry in the valley, producing dairy products, vegetables, and fruit. Orchards have played a leading role since the beginning of the 20th century. People still travel to the county in the summer to buy one item in particular—peaches.

Many historic events have affected life in our valley. From the violent Indian raids of the French and Indian War through service in the Revolutionary War and on through the 1800s, the men of Franklin County fought for liberty. Of those who fought in the Revolution, Gen. Henry Lee of Virginia writes, "They were known by the designation of the 'Line of Pennsylvania,' whereas they might have been with more propriety called the 'Line of Ireland' "—a reference to the high number of Scotch-Irish recruits.

It would be the circumstances surrounding the military actions of the Civil War that would bring us special prominence. As early as 1862, Gen. J.E.B. Stuart raided the area, capturing horses, picking up ammunition and even clothing, and burning bridges. The following year, en route to Gettysburg, General Lee himself moved into Franklin County with many troops; again, food and horses were commandeered. A short time later, during the retreat after the battle at Gettysburg, another little-known battle (only now being recognized by historians) took place in the county— the Battle of Monterey Pass. An interpretive site and visitor's center is planned to mark this action, which stretched over an area of 17 miles.

At the end of July 1864, the Confederates returned once again, this time under the command of Brig. Gen. John McCausland. McCausland had been ordered by Gen. Jubal Early to capture the town and demand a ransom of either $100,000 in gold or $500,000 in greenbacks or suffer the consequences. When the town refused to pay the ransom by daylight on July 30, the main part of the downtown area was set on fire, and soldiers began robbing businesses and homes indiscriminately. According to Alexander McClure, local author and newspaperman, "The main part of town was enveloped in flames in 10 minutes. One million in property [was lost] and 3000 people [left] homeless." Claims for compensation were made to the government, but no payment was ever forthcoming.

By the late 1800s and early 1900s, recreational areas were being developed in the valley, especially a group of mountain resorts where wealthy families from Baltimore and Washington and other nearby cities would come during the summer months. At one time, over 100 hotels and boarding houses served summer vacationers in the mountains of Blue Ridge. Urban people began to buy land and build elaborate cottages—Wallis Warfield Simpson (the future Duchess of Windsor) would be born in one of them—and the resort area would become a summer destination for presidents, ambassadors, and other celebrities. At the same time, popular parks were developed at Caledonia, Mont Alto, and Red Bridge as affordable vacation spots for the working class. Baseball began to be a favored pastime.

In the 20th century, several decades of peace and prosperity made life more comfortable and transportation difficulties were eased by the invention of the automobile. Reformers and Progressives were well represented in the Cumberland Valley by citizens like the Dock sisters. Mira Lloyd Dock, an early conservationist, taught at the Forestry School in Mont Alto and was the first woman to be appointed to a government commission—the State Forest Reserve Commission. Her sister Lavinia crusaded for reforms in health and government and fought for universal suffrage. The valley also fared better than most during the Depression of the early 1930s, not one bank having to close.

Today, our valley remains a destination. Tourists come for the history, the recreation, and the culture, and some stay because they find it a great place to live, work, and play.

The images in this postcard book provide a glimpse into our history—into the path taken by our forebearers. The stories will hopefully be enjoyable, and you might even recognize places and events holding special memories for you.

One

PEOPLE, EVENTS, AND CELEBRATIONS

Born in Cove Gap near Mercersburg in 1791, James Buchanan was the second child in a family of 11 and the only native Pennsylvanian to become president of the United States. The Miss Lane mentioned on the postcard was Harriett Lane, a niece of Buchanan who, orphaned, became his adopted daughter and served as his hostess during his White House days. This postcard was based on a portrait painted for Harriett Lane in 1831.

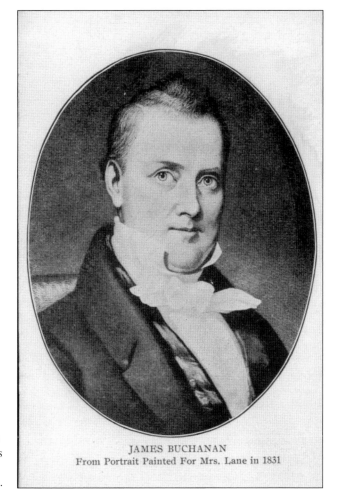

JAMES BUCHANAN
From Portrait Painted For Mrs. Lane in 1831

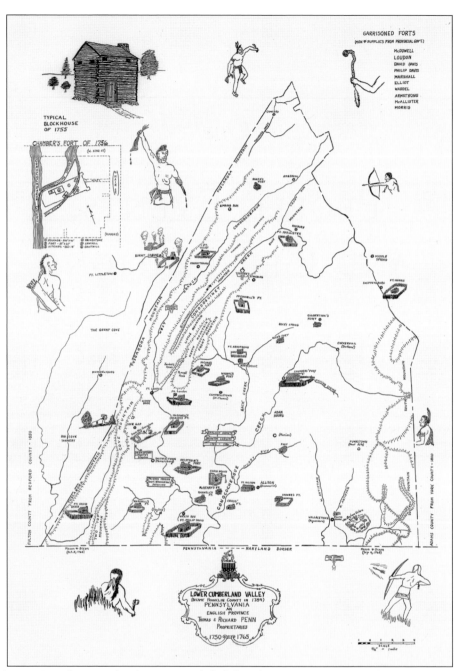

In the 1750s and 1760s, the frontier was left defenseless against massive Indian incursions into the Cumberland Valley and no relief was forthcoming from the colonial government. The Indian fighter Col. John Armstrong, commander of the militia, wrote to the governor, "I'm of opinion that no other means than a Chain of Blockhouses along or near the South side of the Kittatinny Mountain from Susquehanna to the Temporary Line can secure the Lives and Properties even of the old Inhabitants of this country." Settlers needed to find their own protection by building forts, particularly on the western line of the valley. Historian Murray Kauffman researched and produced this map of the forts of the lower Cumberland Valley during that crucial time period.

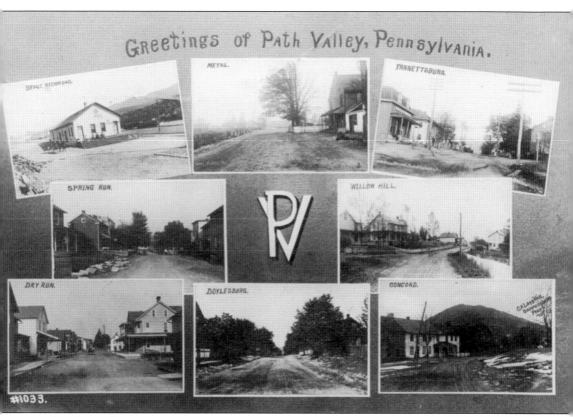

Locals refer to this narrow valley between mountains as "up in the valley." Actually called Path Valley, it includes the villages of Richmond Furnace, Metal, Fannettsburg, Spring Run, Willow Hill, Dry Run, Doylesburg, and Concord. Path Valley was named for an old Indian trail known originally as the Tuscarora Path. (Courtesy of Kay Feight.)

At the uppermost point of the valley in Franklin County lies the village of Concord. Its name was derived from one of the battles that opened the Revolutionary War. It is situated on the Tuscarora Creek. The first church services in the valley were held by Bishop Francis Asbury of the Methodist Episcopal denomination. (Courtesy of Kay Feight.)

The village of Dry Run, located on the West Conococheague Creek, was founded by Stephen Skinner in 1838. It was first named Morrowstown, and an academy was built there as early as 1874. Today, many Amish people have moved to farms in this rural area as it is more closely attuned to their way of life. (Courtesy of Kay Feight.)

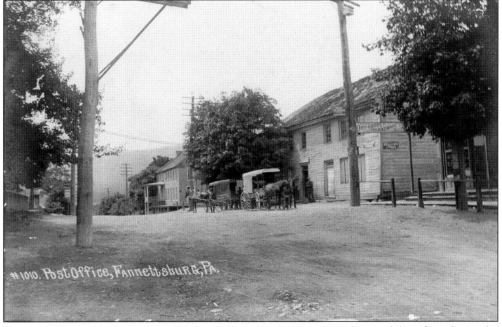

Fannettsburg was laid out in 1792 by William McIntire, who advertised lots for sale in the Chambersburg newspaper. The town included a distillery where "genuine old rye" was made. It became important during the Whiskey Rebellion, when there were found to be many supporters here. (Courtesy of Kay Feight.)

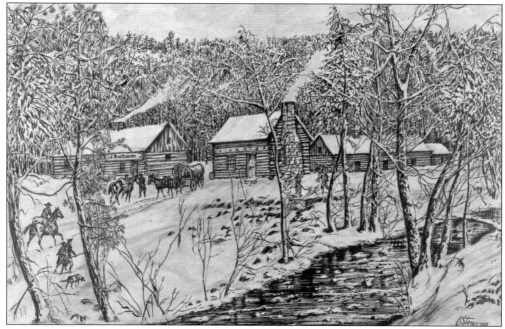

This wonderful pen and ink drawing is by local artist Charles Stoner. The John Tom's Trading Post, located in Larraby's Gap (also known as Foltz, but now Cove Gap), marked the end of a wagon road and the beginning of a horse trail to Fort Pitt. James Buchanan, father of the president, purchased the post in 1788 and renamed it Stony Batter after the Buchanan home in North Ireland. After a wagon road was built across Cove Mountain and the Tuscaroras early in the 19th century, the old trading post was no longer needed. (Courtesy of Harry Oyler.)

For a period of time in the mid-1900s, the log cabin where Buchanan was born was moved to Second Street in Chambersburg and was the headquarters for the Girl Scouts. The building to the right, built in 1884, was the home of the Junior Hose and Truck Fire Company No. 2.

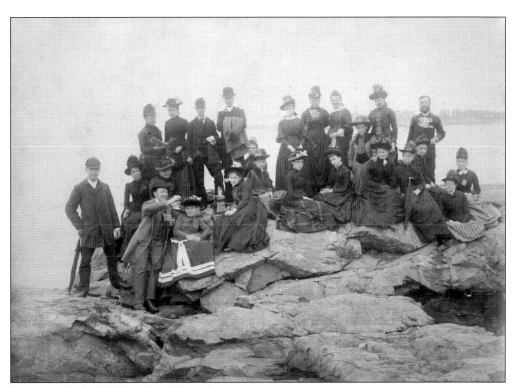

An outing in the 1890s to Pen Mar—the most elaborate and well known of the area resorts—included about 25 formally dressed young people enjoying themselves. Notice the woman a little left of center, the picnic basket, and the "package" wrapped in a bow.

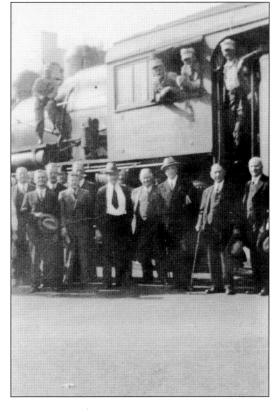

The back of this postcard reads, "Last train through center square—Greencastle," which dates the image to 1936, when the tracks through the middle of the town were removed. The impressive gentleman standing third from the right is Henry P. Fletcher, a native of Greencastle who was one of Theodore Roosevelt's Rough Riders and later US ambassador to Italy and chair of the National Republican Party.

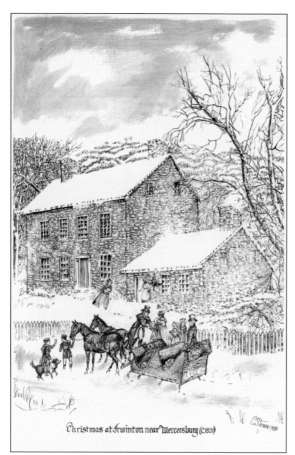

Christmas at Irwinton near Mercersburg (c1800)

The pen and ink drawing by Charles Stoner at left reflects the beauty of the Irwinton Estate (near Mercersburg) in winter. It was settled in the 1760s by Archibald Irwin, whose daughters Jane (below left) and Elizabeth (below right) married into the Harrison line. Jane married William Henry Harrison Jr. As daughter-in-law to the president, she became mistress of the White House for a short period. Elizabeth married the president's other son, John Scott Harrison, and became the mother of Benjamin Harrison, the 23rd president of the United States. The likenesses of the women below were taken from portraits. (Both courtesy of Harry Oyler.)

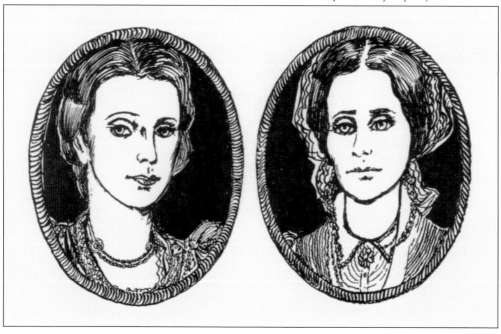

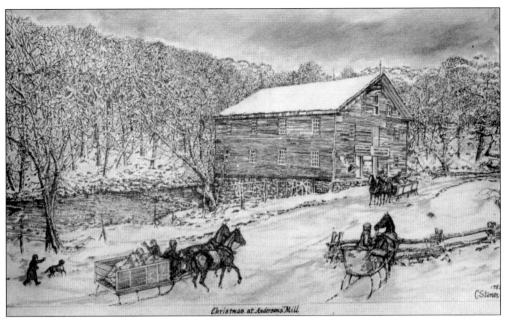

"Christmas at Anderson's Mill" is the title of this pen and ink drawing by Charles Stoner. Anderson's Mill was located directly across from Irwinton and was originally the site of Archibald Irwin's grist mill. It remained in the Irwin family until the 1840s. Since 1917, it has been in the Anderson family. No longer functioning as a mill, it has been occasionally opened to the public for historical tours. (Courtesy of Harry Oyler.)

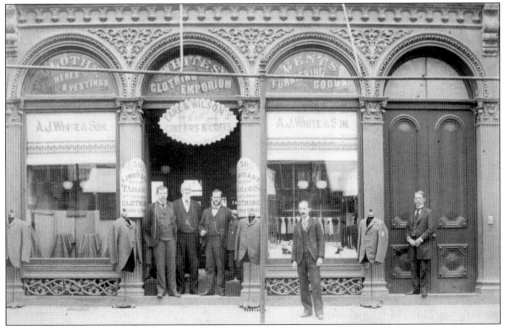

A.J. White & Son, Practical Tailors and Clothiers, were located at 36–38 South Main Street in Chambersburg. Established in 1858, this photograph of the storefront was taken in 1890. A.J. White is standing in the private residence door on the right, and H.C. White is standing on the left side of the group in the store door. The other three men are unidentified but may be store employees.

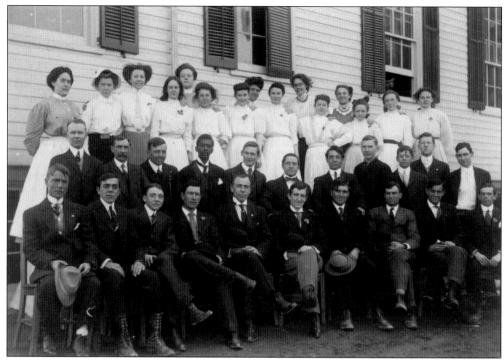

Mont Alto Sanatorium, sitting on top of the Blue Ridge Mountains, was established to care for patients whose respiratory systems were compromised by disease, usually tuberculosis. Sanatoriums were typically built in mountainous locations to benefit from both purer air and isolation to insure minimal spread of the disease. These postcards are thought to show doctors, nurses, and attendants in the early 1900s. Today, known as the South Mountain Restoration Center, it is the only state-run institution of its kind providing long-term nursing care for mostly elderly people.

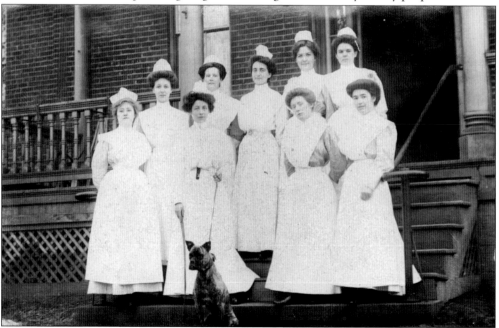

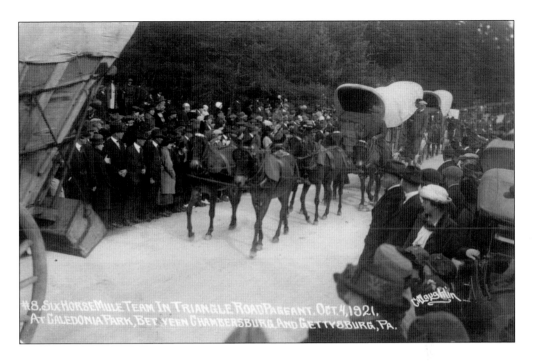

These two images record the Triangle Road Pageant—a pageant depicting progress in road transportation—held at the formal opening of the Harrisburg-Gettysburg-Chambersburg Road at Caledonia Park on October 4, 1921. The card above is from Theodore Wood Jr. and relates that he was at the pageant with his father. The card below reads, "W.M. Hafer walking beside horses; his teams pulled wagons in many parades." Notice the contrasting modes of transportation—horse and wagon next to automobile.

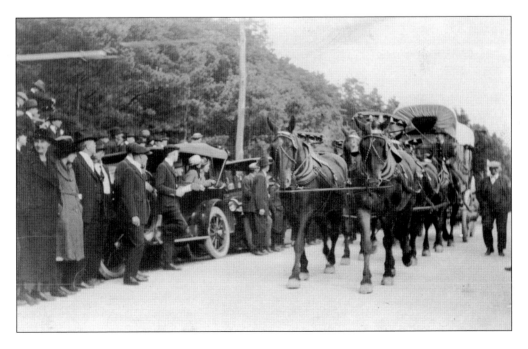

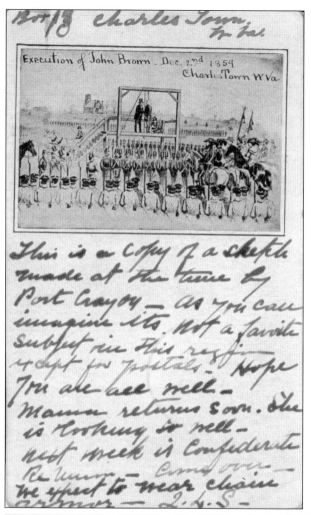

Box 13 Charles Town,
Wr Va.

Execution of John Brown. Dec. 2nd 1859
Charles Town W Va

This is a copy of a sketch
made at the time by
Port Crayon — as you can
imagine its. Not a favorite
subject in this region
except for postals. Hope
you are all well. —
Mamma returns soon. She
is looking so well —
next week is Confederate
Re union — come over —
we expect to wear chain
armor — J. A. S. —

This postcard is addressed to James Cree in Chambersburg from Charlestown, West Virginia. In 1906, shortly before his death, Cree wrote an article for the Kittochtinny Historical Society (subsequently Franklin County Historical Society–Kittochtinny) on John Brown in Chambersburg, remembering that definitive time in 1859. Is the writer apprehensive about the following week's Confederate Reunion or is he being facetious?

The back of this sterioptic card indicates that this is a meeting at Central Presbyterian Church in Chambersburg. Included in this photograph from the 1870s are, from left to right, (first row) unidentified, Dr. James Kennedy, and Dr. Lane; (second row) Dr. John Caldwell, S.A. Mowers, Robert Cline, W.C. Cremer, A. Stewart Hartman, and Dr. George Miller. This might be one of the earliest meetings of the ministerium.

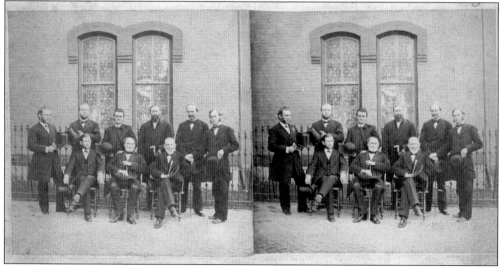

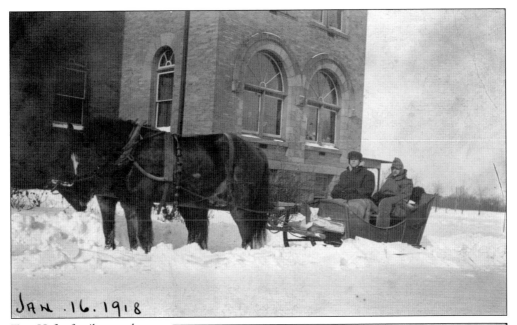

Jan. 16. 1918

Two Hafer family members (Ralph and William) appear to be riding in a sleigh on this postcard from 1918. The back of the card indicates that the photograph was taken at the Scotland School for Veterans' Children. Originally named the Pennsylvania Soldiers' Orphans' Industrial School, it was the last of the schools established by Gov. Andrew G. Curtin in the years following the Civil War. It opened in 1895 on the former farmland of state senator Alexander Stewart and provided something as close to a home setting as possible while educating children from grades one through twelve.

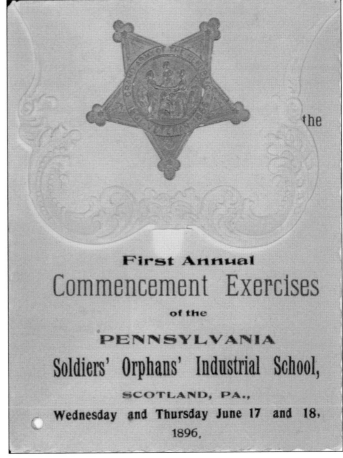

the

First Annual
Commencement Exercises
of the

PENNSYLVANIA
Soldiers' Orphans' Industrial School,
SCOTLAND, PA.,
Wednesday and Thursday June 17 and 18,
1896.

In the early 1900s, moving houses and other buildings to new locations was a regular occurrence. Hafer Construction Company employees are gathered here for a picture-taking event prior to such a move. The owner, William Hafer, is in the second row, third from the right, with the cocked hat.

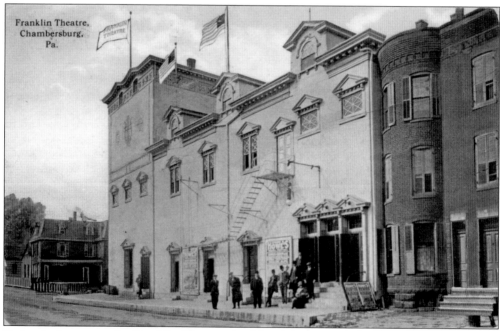

Variously known as the Franklin Theatre, the New Theatre, and the Orpheum Theatre, this building opened in 1911 with a showing of a vaudeville "shorty." It was acquired from the Franklin Guards Association and had previously been used as a skating rink. There were other theaters in town, including the Rosedale on North Main Street, the Star on Lincoln Way East (where the courthouse annex is now), and the Palace on South Main Street. This image is from 1913, seven years before the building burned to the ground. The *Public Opinion* newspaper quoted the firemen, who suggested it was caused either by a carelessly thrown cigarette or defective wiring. (Courtesy of Kris Greenawalt.)

At the east point of Chambersburg's boundary stood the new Friendship Fire Company headquarters, built in 1911. Formed in the 1790s, the "Friendships" were the earliest fire company in Chambersburg and were known for their red helmets and capes. Sometime in the early 1800s, they were said to have enough water pressure in their hoses to knock the rooster off the spire of the old courthouse.

County employees posed for this postcard in 1912. "Judge" John Atherton was the county surveyor from 1924 to 1960. He graduated from the Chambersburg Academy and then from Penn State with a degree in civil engineering. He is kneeling, first row center, behind the transit. The others are not identified.

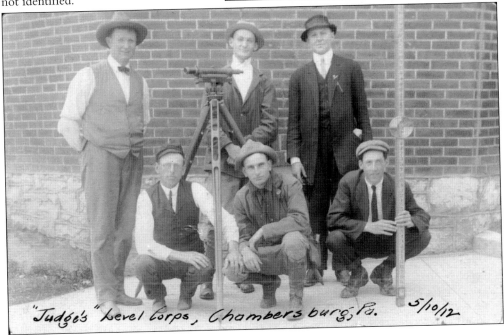

"Judge's" Level Corps, Chambersburg, Pa. 5/10/12

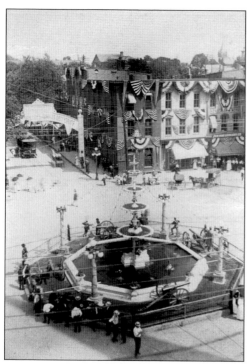

Old Home Week in Chambersburg, held from July 26 to August 1, 1914, celebrated not only the 150th anniversary of the founding of Chambersburg, it also commemorated the 50th anniversary of the burning of Chambersburg. The area around the Diamond was elaborately decorated, and at exactly 11:55 p.m. on Saturday the 25th, the bells of every factory, firehouse, church, and other buildings rang out to welcome in the event. Over the next week, thousands came to participate or watch the parades and games scheduled each day and the special services held on Sunday. Monday was set aside as the day for honoring Chambersburg's founder, Col. Benjamin Chambers, by placing flowers on his tombstone.

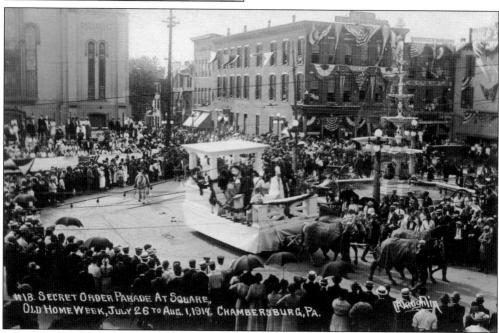

#18. SECRET ORDER PARADE AT SQUARE, OLD HOME WEEK, JULY 26 TO AUG. 1, 1914, CHAMBERSBURG, PA.

There were various parades during Old Home Week in Chambersburg in 1914, including this secret-order parade held on Tuesday, July 28. It was an innovative idea for the time and included many of the fraternal orders, lodges, and secret societies of Chambersburg. Some of the secret orders included the Canton of Patriarchs Militant, Chambersburg Castle Knights of the Golden Eagle, Ancient and Illustrious Order Knights of Malta, Lake Victoria Lodge Daughters of Rebakah, and Sons of America. (Courtesy of Adda Higgens.)

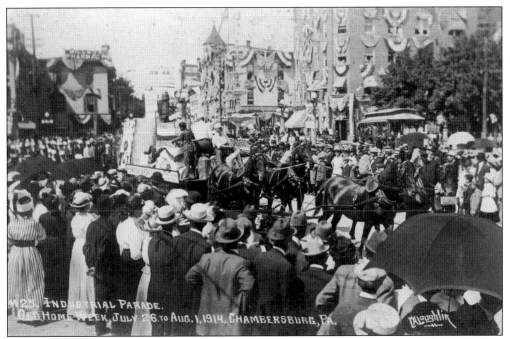

The industrial parade was held on Wednesday, July 29, and included the women's suffrage float, which had been barred from the secret order parade the day before. The committee took "peculiar action after a long argument" about admitting the women but only after the Socialists withdrew their float.

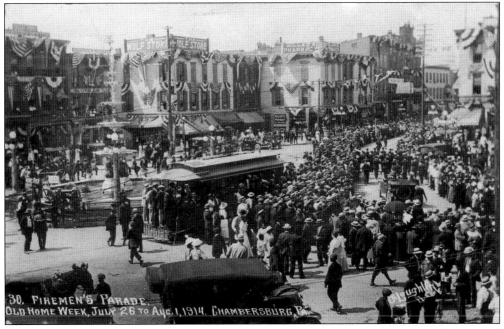

The firemen's parade took place on Thursday, July 30, and attracted the largest crowd. A total of 24 fire companies participated, coming from as far away as Maryland, Virginia, and West Virginia, making it one of the largest of all the parades.

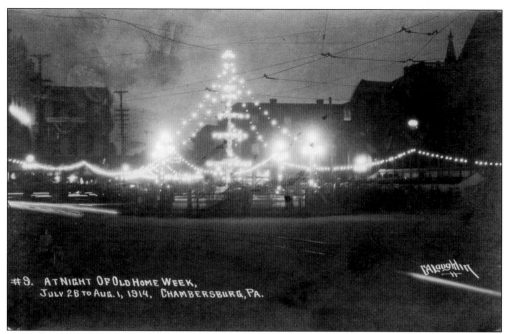

The *Franklin Repository* newspaper of August 1, 1914, wrote, "Never were as elaborate or general attempts made to beautify and adorn the town with flags, bunting, and banners." The biggest feature was the electrical illumination at night, which was a sight to behold at that time. The memorial fountain and surrounding fence were covered with colored bulbs and arches of light spread over five square blocks.

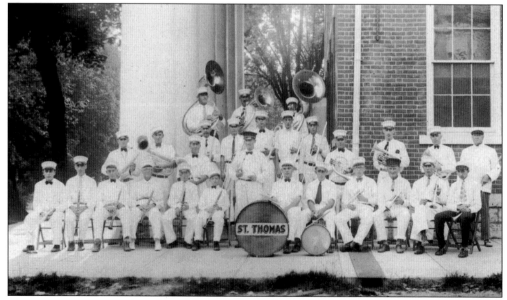

The St. Thomas Band was organized in 1872, according to the minutes of a meeting held December 17 at the Campbell School building. The bylaws allowed for a fine of 50¢ for unexcused absences; it was later increased to $1. It was one of the few bands in the county that wasn't a school band. This photograph shows the band in 1930 in front of the Fulton County Courthouse. (Courtesy of Kris Greenawalt.)

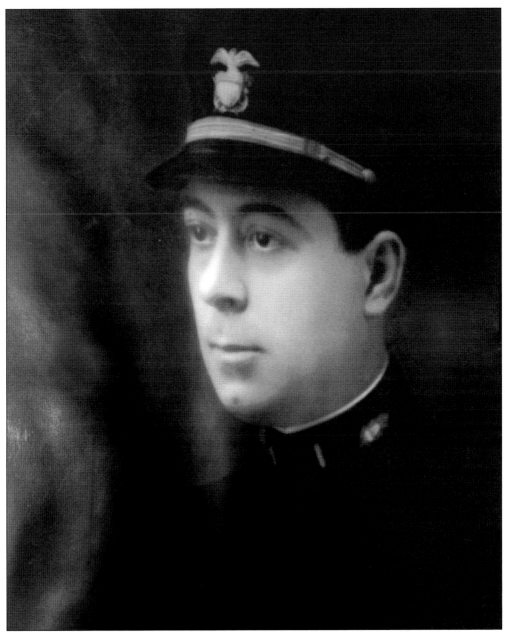

Burt J. Asper, M.D., a native of Chambersburg, graduated from Chambersburg High School and entered the school of medicine at the University of Maryland. He never practiced medicine in Franklin County, but he retained his residence in Chambersburg, entering the US Navy from there. He joined the medical corps and was ordered to active duty just before World War I. He was appointed lieutenant junior grade in May 1917 and assigned to the USS *Cyclops*, which was part of the transport of the original Pershing expedition to France. The *Cyclops* was sent as a relief ship during the Halifax disaster and sailed to Rio de Janeiro, Brazil, in 1918. On its return trip, after leaving Barbados, the ship, with all on board, vanished in the Bermuda Triangle. Nothing has ever been found to give a clue as to the fate of the vessel or of any crew members. American Legion Post 46 in Chambersburg was named in Asper's honor.

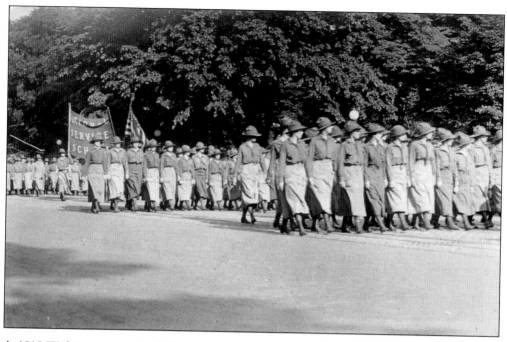

A 1918 Washington parade of the National Service School included two Chambersburg girls, Mary Boyd and Peggy Kennedy. This organization was part of the YMCA and was the first to send professional workers overseas to provide leadership and support to US armed forces in World War I. By war's end, the YMCA, through the United War Work Council, had operated 1,500 canteens in the United States and France, set up 4,000 huts for recreation and religious services, and raised more than $235 million for relief work. As can be seen from Mary Boyd's certificate, these girls were part of the National War Work Council, which worked behind the lines in Europe.

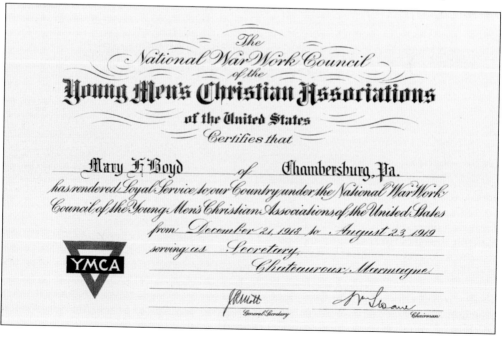

Two

VILLAGES, TOWNS, AND CROSSROADS

In 1782, Col. Benjamin Chambers built this stone mansion on the corner of North Main and Chambers Streets in Chambersburg for his eldest daughter, Ruhamah, and her husband, Dr. John Calhoun. In 1788, when he was 80, Chambers died in the house while visiting his daughter. The original house had a basement kitchen; the rooms above, along with a wide hall, formed the south end of the house. The door at the rear has a quaint latch. The stones in the south wall were brought from the Chambers fort stockade. During the 1850s, the house was sold to Daniel Ridgeway Knight, a celebrated artist whose paintings had been shown in the finest galleries in the world. Knight lived in France most of his life but came to Chambersburg for a time to visit relatives who lived here. Today, this is the site of the Sellers Funeral Home.

ROCKY SPRING CHURCH
near Chambersburg, Pennsylvania.

This building was erected in 1794, replacing the original log church erected in 1738.

Annual Service held in June.
Sponsored by
Franklin County Chapter D. A. R.

Rocky Spring Church, sitting on a knoll northwest of Chambersburg, evokes the history of the Scotch-Irish pioneers who settled this area. They were hardened by this uncivilized land but loyal to their faith. Built in 1794, the interior of the church remains unchanged. It retains its overhead sounding board in the pulpit area, original plaster, upright pews, and pew doors with the owners' names on them. Two wood stoves placed there after 1800 helped to heat the church. Listed on the National Historic Register in 1994 to commemorate its bicentennial, it is owned by the National Society Daughters of the American Revolution, Franklin County Chapter, members of which open it once a year in June for a traditional Presbyterian service.

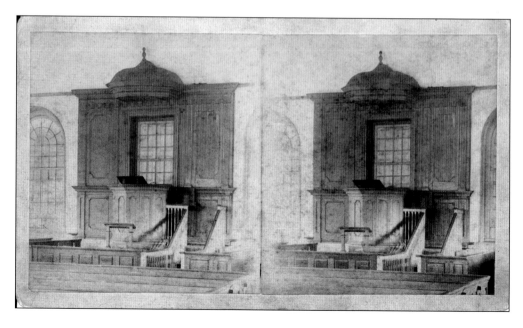

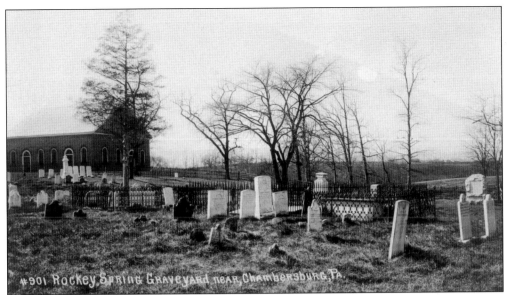

#901 Rockey Spring Graveyard near Chambersburg, PA.

Adjacent to the Rocky Spring Church is its graveyard. Carved on the gravestones are the names of men who fought in the Indian wars, the Revolutionary War, the War of 1812, and the Civil War. A company of rangers from the Rocky Spring congregation was organized as early as 1755 to guard against the Indian forays into the valley. James McCalmont was one of the rangers whose exploits as an Indian fighter are well documented, and he and his parents are buried here. In July 1776, Rev. John Craighead led the men of the congregation in the Revolutionary War as their chaplain and with his company was captured at Long Island. Reverend Craighead is the only pastor buried in the churchyard. A large monument memorializes the Culbertson clan, whose family members fought in all the wars. Sarah Wilson, founder of Wilson College, is buried here in the family plot.

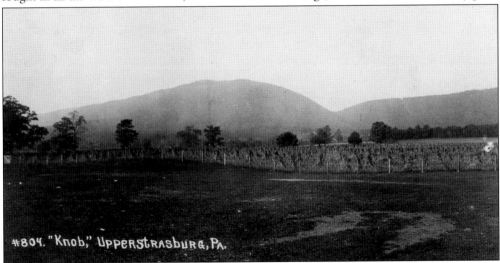

#804. "Knob," Upperstrasburg, PA.

The "Knob" at Upper Strasburg, being part of a larger tract of land known as "Clark's Fancy," was called Clark's Knob. In the late 1700s, Strasburg became a thriving community because of the availability of wood and water. Prosperity increased because of the Three Mountain Road. It was completed in 1793, just in time for President Washington's army to come through in 1794. This toll-free road soon became popular with the heavy Conestoga wagons going west and the herds of animals being driven east to market.

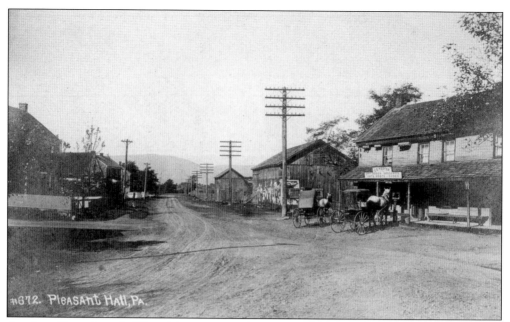

Another village along the Three Mountain Road, which stretched from Shippensburg northwest to Burnt Cabins in Huntingdon County, is Pleasant Hall, a small village of few homes. On his return from western Pennsylvania in 1794, Washington stopped at the Black Horse Hotel (or Tavern) where the bill of fare consisted of old-fashioned potpie. At that time, the Black Horse was the only building in that location and was one of a series of hotels along the Three Mountain Road.

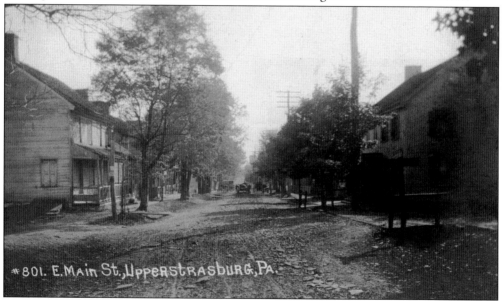

This photograph from the early 1900s was taken in the village of Upper Strasburg, presumably named after the town in Germany (now part of France-Strasbourg) from which the founders had come. The famous Indian fighter James McCalmont who survived the massacre of 1757 came from this village. He came by the name of "Supple McCamont" because he could load his rifle while running and shoot the leading Indian following him. He fought in the Revolutionary War and became a member of the House of Representatives from 1784 to 1788.

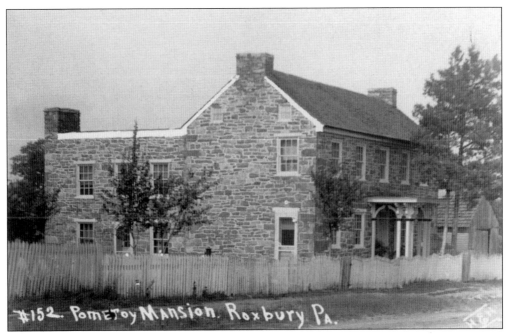

One of the pioneer settlers in the Roxbury area was Thomas Pomeroy. Tradition states that he was a merchant from Liverpool, England, who was pressed into service in the Royal Navy but succeeded in putting his captors to sleep by plying them with liquor and making his escape on a merchant vessel bound for America. He settled in this area in 1730, married, and produced four sons and four daughters. In 1763, while he was away deer hunting, natives massacred his wife and two children. His descendents remained in the area, one becoming a tanner. Evidence of that business no longer exists, but the Pomeroy Mansion remains, an old stone building with a brick extension.

The earliest name for this gap was McAllister's Gap, named for James McAllister, who arrived around 1760. A fort with the same name, of which no trace remains today, existed in that same period, probably built as a private fort for protection against the Indians. Between the mountains within the gap, a furnace called Soundwell Forge was built around 1789, followed in 1815 by nearby Roxbury Furnace.

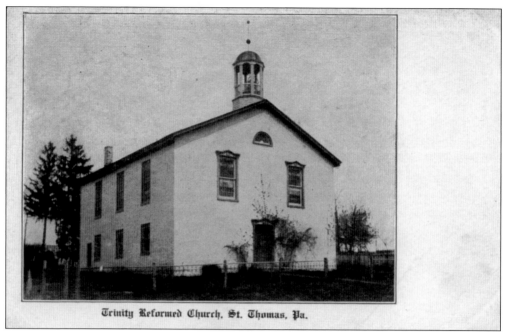

Trinity Reformed Church, St. Thomas, Pa.

Trinity Reformed Church in St. Thomas was built in 1853. Before that time, a log structure was shared by Reformed, Lutheran, and Presbyterian congregations, with baptisms recorded as early as 1764. In October 1862, a Mary Deatrich climbed into the belfry and sounded a warning to the village that Confederate troops were fast approaching. (Courtesy of Kris Greenawalt.)

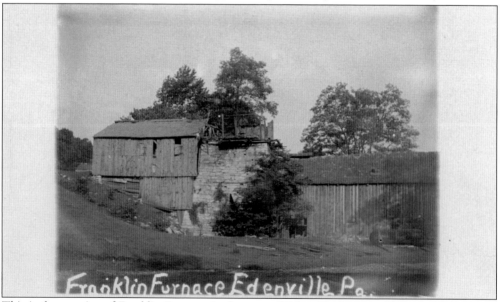

Franklin Furnace Edenville Pa.

This is the remains of Franklin Furnace in the area of Edenville. Built in 1828, the first owners were Peter and George Housum. At its peak, 75 to 100 men were employed there, forming a sizable community. The furnace closed in 1884. The last owners were John Hunter and Levi Springer. Iron ore was plentiful in Franklin County, and many furnaces were built and prospered until the 1880s, when there was no longer a railroad to haul the iron that was produced. (Courtesy of Kris Greenawalt.)

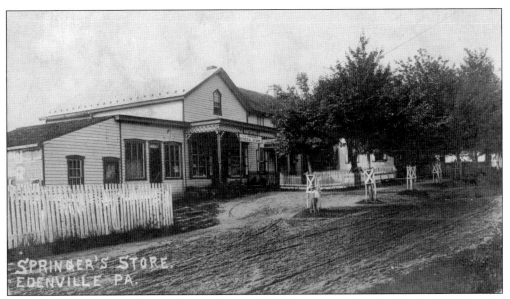

Edenville, located about three miles northwest of St. Thomas, was founded by Levi Springer in 1882. Springer chose the location, which was to include a general store, for its proximity to the Franklin Furnace. The name Edenville (from the Garden of Eden) was chosen by his wife, Louisa, who was impressed with the beauty of this area. (Courtesy of Kris Greenawalt.)

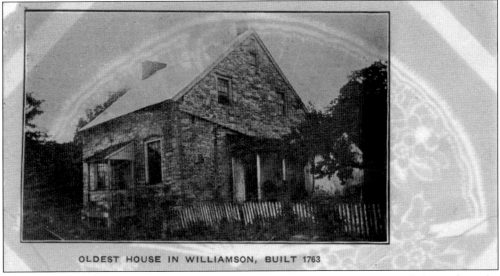

OLDEST HOUSE IN WILLIAMSON, BUILT 1763

Although Williamson wasn't recognized as a village until 1870, the area was settled as early as the mid-1700s. From colonial records, it is known that John and Ann Wasson owned 450 acres called Rockdale Farm near the present village of Williamson. In May 1756, after leaving their seven children at Fort Steel, they went out to work on the farm and were attacked by Indians. John was killed and Ann taken prisoner. Three years later, she was released and taken to Philadelphia where, at the colonial council, she told of her captivity and that she had left seven children "two miles off and hope[d] they [were] alive somewhere." She was later reunited with some, if not all, of the children. Records indicated that by 1769, she was a member of the Upper West Conococheague Presbyterian Church. The background design is original to the postcard. (Courtesy of Kris Greenawalt.)

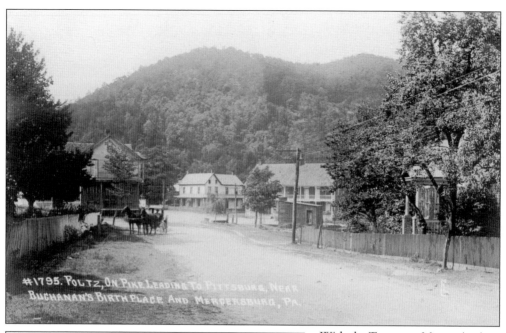

With the Tuscarora Mountains in the background, this tranquil scene recalls the village of Cove Gap on the pike leading to Pittsburgh. Pres. James Buchanan's birthplace is nearby.

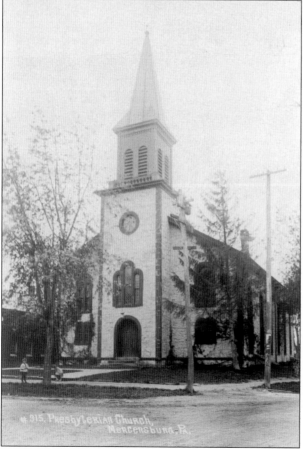

Originally known as the Presbyterian Church of the Upper West Conococheague, this stone church was built in 1794 to serve the growing Presbyterian population of Mercersburg. As early as 1732, there had been a log meetinghouse several miles south of Mercersburg at Church Hill. It stood within a stockade, erected to provide protection from the Indians, and was called Fort Steel after its first minister.

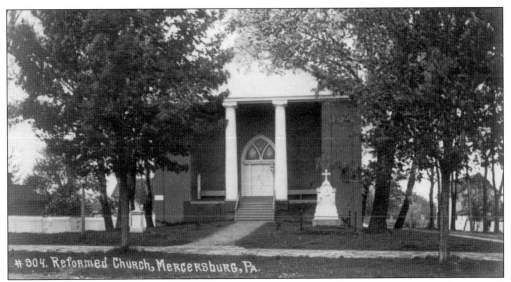

Trinity Reformed Church was built in Mercersburg in 1845, but documents show that a small group of German Reformed congregants were meeting as early as the 1780s in a small stone church. The new church, shown on the card, included for the first time an instrument in the gallery—a small reed organ or melodeon. The introduction of instrumental accompaniment in the church service was entirely new and shocking to the more conservative members, who nicknamed the organ the "German Reformed Gyascutus" (a large mythical creature known for emitting weird noises).

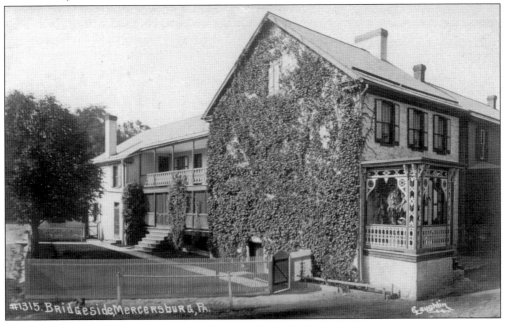

Bridgeside, built as early as 1810, is known for its rich history. One incident featured the Confederate general, J.E.B. Stuart. On October 10, 1862, Stuart raided Mercersburg and took lunch on this porch as an uninvited guest of the owners. Mrs. Steiger served bread, butter, and milk to Stuart and his officers before they departed for their goal of Chambersburg. The home remains in the Steiger family today.

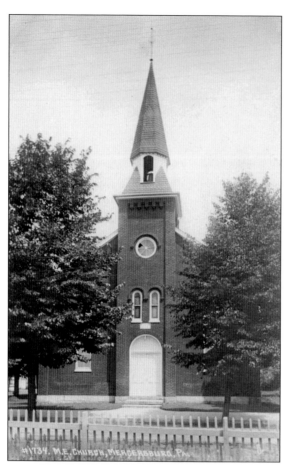

#1734. M.E. CHURCH, MERCERSBURG, PA.

Cornerstone-laying ceremonies for this Methodist church in Mercersburg took place in 1834. Prior to that date, the congregation relied on traveling preachers, or "circuit riders," who were clergy assigned to travel to specific locations to minister to the settlers and to organize congregations. The basement of the church was used as a hospital during the Civil War, and 200 wounded Confederate soldiers were cared for in Mercersburg after the Battle of Gettysburg.

Evidence of Lutherans in Mercersburg can be found as early as 1765, but no church was built until 1813. This photograph shows the second church, a red brick structure built in 1868 in the Corinthian style, with a tall spire. The first pipe organ, an Estey, was installed in the early 1900s. A new Moller organ was installed only after World War II, having been delayed by the lack of both materials and workers during the war years.

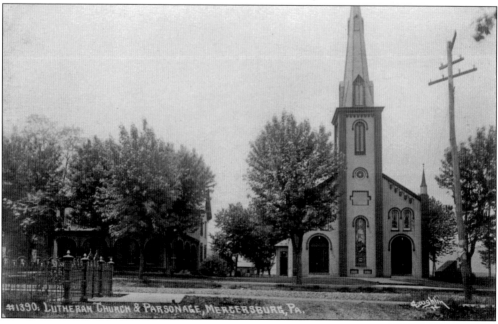

#1390. LUTHERAN CHURCH & PARSONAGE, MERCERSBURG, PA.

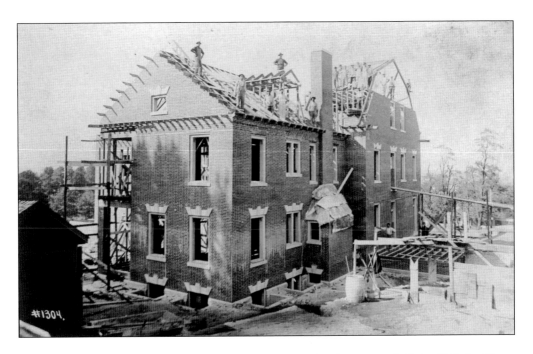

These two postcards show Prospect, the lovely Georgian brick mansion built in 1909 for Harry Byron, co-owner of the Mercersburg Tannery. The builder was Quigley Hafer of Chambersburg, who documented photographically all of his construction company's projects. Byron had the foundation of the building extended when he realized that the basement would not accommodate a bowling alley. Although it has had several owners over the years, it would now be recognized as the Mercersburg Inn, a 15-room bed and breakfast where the specialty is French cooking classes on weekend getaways.

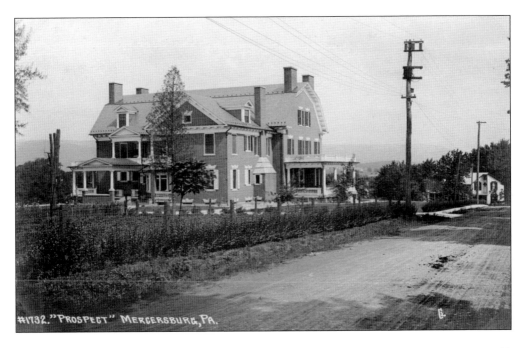

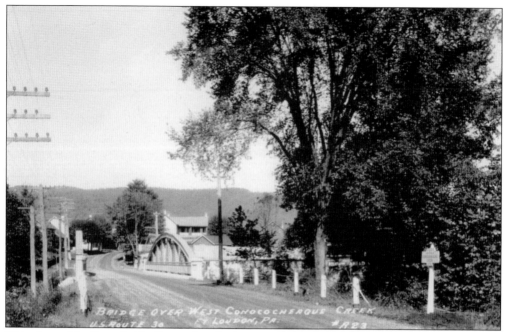

BRIDGE OVER WEST CONOCOCHEAGUE CREEK
U.S. ROUTE 30 FT LOUDON, PA. #R23

This view of the "new bridge" was taken looking east into the village of Fort Loudon, named for the fort nearby. Built in 1756 by Col. John Armstrong as protection for the early settlers against Indian attacks, the fort was abandoned in 1765 at the end of the French and Indian hostilities.

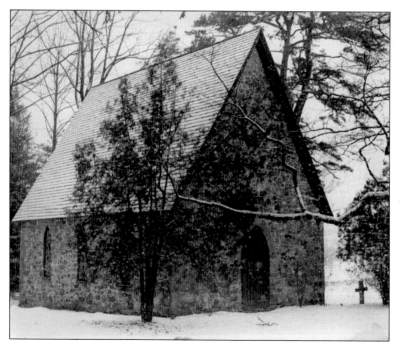

Emmanuel Chapel in Mont Alto was built in 1854 as the first Protestant Episcopal church west of the Blue Ridge Mountains. Its special fame comes from the fact that the great abolitionist John Brown taught Sunday school here during the summer and fall months when he was traveling about Franklin County in 1859. Today, it is part of the campus of Pennsylvania State University–Mont Alto.

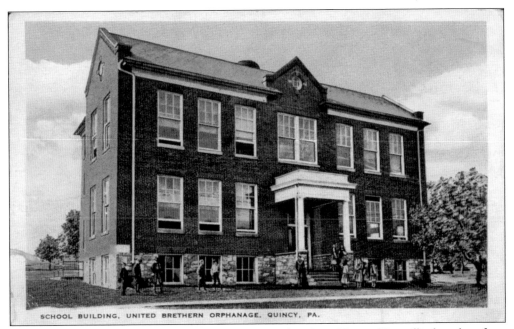

SCHOOL BUILDING, UNITED BRETHERN ORPHANAGE, QUINCY, PA.

The Quincy Home began as an orphanage in 1903 when Rev. Harvey Kitzmiller bought a farm in the area of Quincy Village and donated it to the United Brethren Conference. Gov. Samuel Pennypacker spoke at the dedication on October 17, 1903. From 1915 to 1971, the home served as both an orphanage and an old people's home. Today, it is the Quincy Village Retirement Home.

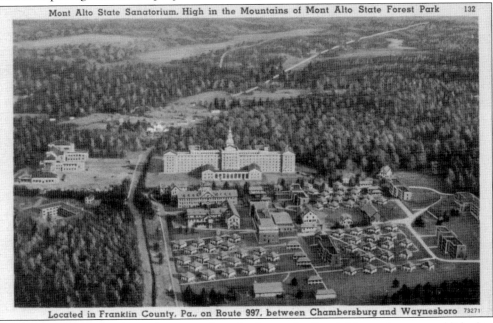

Mont Alto State Sanatorium, High in the Mountains of Mont Alto State Forest Park 132

Located in Franklin County, Pa., on Route 997, between Chambersburg and Waynesboro 73271

Mont Alto Sanatorium, located on state forest land near the South Mountain, was established in 1902 by Dr. Joseph Rothrock as a private sanatorium for the care and treatment of individuals with tuberculosis. The sanatorium was taken over by the state health commission in 1907, when Dr. Samuel Dixon was the state commissioner. In this 1950 view is the sanatorium as it would appear from Snowy Mountain Fire Tower.

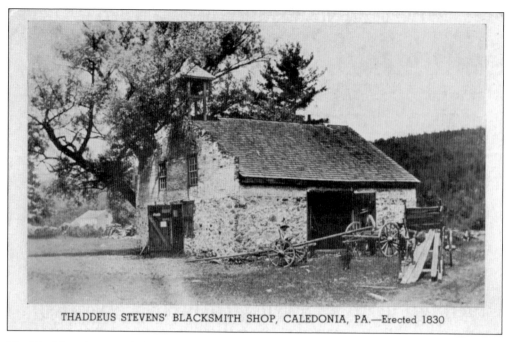

THADDEUS STEVENS' BLACKSMITH SHOP, CALEDONIA, PA.—Erected 1830

The Thaddeus Stevens Blacksmith Shop is the only surviving part of the extensive furnace works called Caledonia Forge, where pig iron was processed. Stevens was well known in the South as an abolitionist leader. When the Confederates, under Gen. Jubal Early, traveled through on their way to Gettysburg, they did not miss the chance to raid and destroy the property. Stevens had supported the free black community nearby by employing them in the iron business. This area had also played an active part in the Underground Railroad, with fugitives being able to blend into the communities.

10933

Caledonia Park
Chambersburg, Pa.

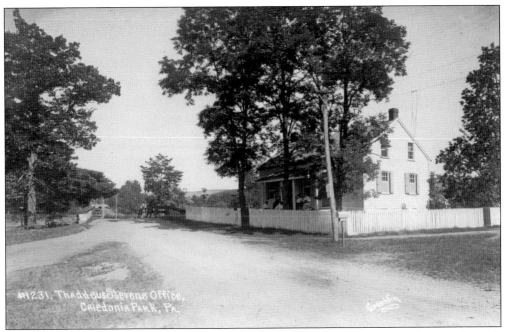

Thaddeus Stevens's office was the only building left standing after General Early came through Caledonia, but on their way back from Gettysburg, the Confederates fired it. With the exception of the lower forge and the rolling mill, the buildings were rebuilt and business resumed until Stevens died in 1868.

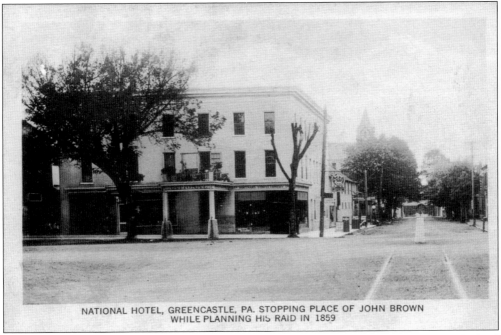

NATIONAL HOTEL, GREENCASTLE, PA. STOPPING PLACE OF JOHN BROWN
WHILE PLANNING HIS RAID IN 1859

During the planning of the Harpers Ferry raid, John Brown was moving about the Cumberland Valley, transporting his "hardware" (weapons) south to the Kennedy Farm in Maryland. The National Hotel in Greencastle was one of his resting places.

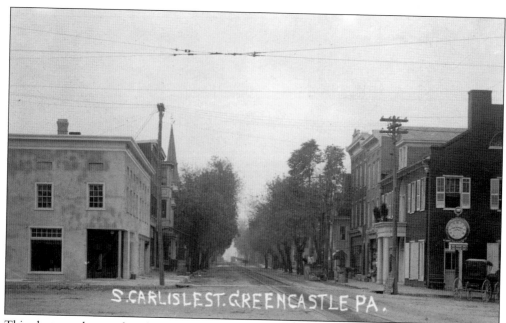

This photograph was taken facing south on Carlisle Street in Greencastle. The building on the left was the McCullough Hotel, where Pres. George Washington stopped for breakfast on his way west to quell the Whiskey Rebellion. Notice the railroad tracks running north and south, while the overhead trolley lines run east and west.

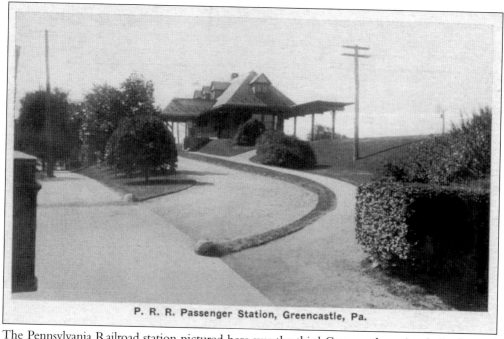

The Pennsylvania Railroad station pictured here was the third Greencastle station built. Opened in February 1909, it was located on the Jefferson Street highline rather than in the center of town. The new location caused some inconvenience in those pre-automobile days.

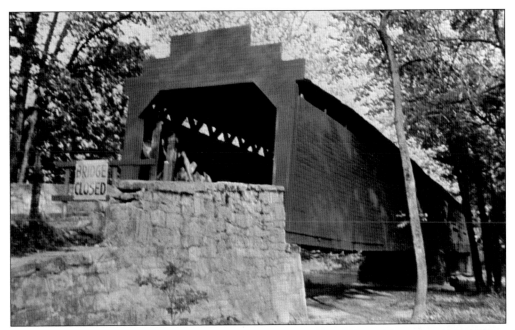

The Martin's Mill Bridge, one of the few covered bridges in the county, was built in 1849 over the Conococheague Creek, three miles southwest of Greencastle. After the destructive flood of 1972 caused by Hurricane Agnes, major portions had to be rebuilt, including the last restoration in 1995.

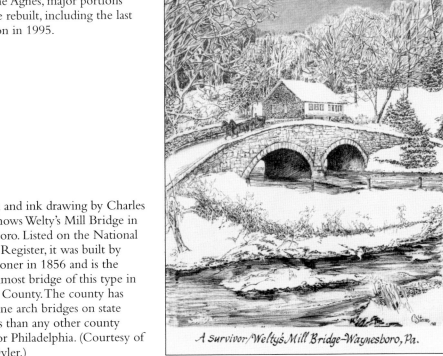

A survivor/Welty's Mill Bridge-Waynesboro, Pa.

This pen and ink drawing by Charles Stoner shows Welty's Mill Bridge in Waynesboro. Listed on the National Historic Register, it was built by David Stoner in 1856 and is the southernmost bridge of this type in Franklin County. The county has more stone arch bridges on state highways than any other county except for Philadelphia. (Courtesy of Harry Oyler.)

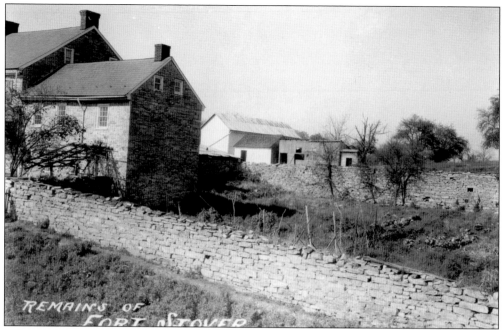

REMAINS OF
FORT STOVER

A Brethren bishop, William Stover, erected this stone fort in the Marsh Creek area between Waynesboro and Greencastle around 1756. It originally consisted of a small stone house and barn with additions made during the late 1700s. There were gun slits placed between the stones in the house, although the Indians are not known to have ever attacked this place. Bishop Stover sent three sons to fight in the Revolutionary War. The upper card shows the remains of the fort; the lower card, from a 1949 drawing, shows what it may have looked like with the additions.

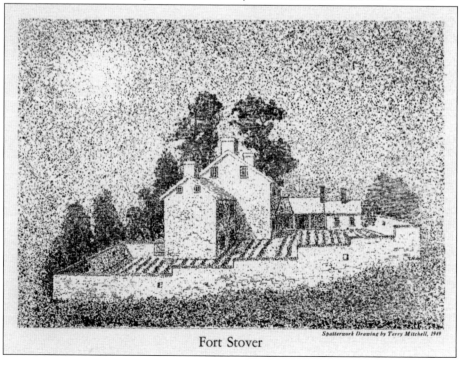

Spatterwork Drawing by Terry Mitchell, 1949

Fort Stover

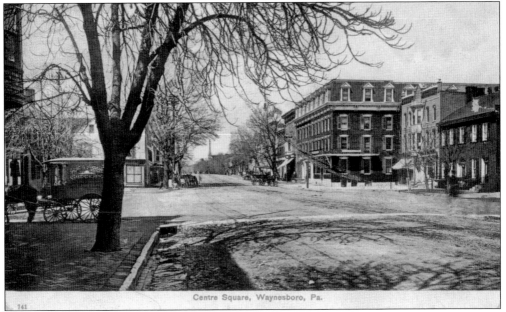

Centre Square, Waynesboro, Pa.

This photograph of Centre Square in Waynesboro was taken looking west toward Greencastle. The house on the far right was built in 1828 and served as headquarters during the Civil War for Union general Thomas Neill. He was there awaiting orders from Gen. George Meade. Some time later, Neill sent a silver cup to the owner, George Besore, in appreciation for kindnesses shown during that July in 1863.

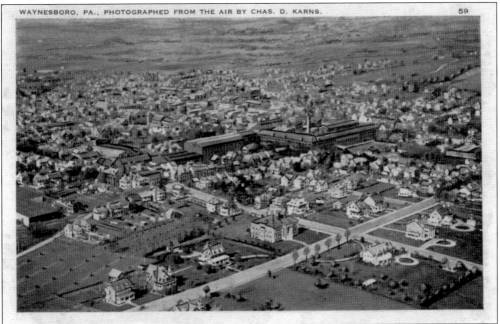

WAYNESBORO, PA., PHOTOGRAPHED FROM THE AIR BY CHAS. D. KARNS. 59

This aerial photograph, taken in the 1920s, shows the Geiser Manufacturing Company (the large building in the center), which burned in 1940. Geiser Manufacturing invented the grain separator and a circular, steam-operated sawmill. The company won many awards and exhibited its products at both the Cincinnati Exposition in 1881 and in Louisville in 1883.

47

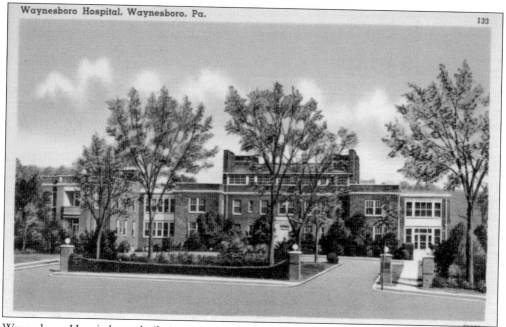

Waynesboro Hospital was built in 1922 in response to the influenza epidemic during the fall of 1918, for which the town had been ill prepared. Emergency hospitals had to be set up in the YMCA building and at the firehouse, and 40 people are known to have died. By December, the epidemic had run its course. Contemporary accounts mentioned such home remedies as placing plates of sliced onions throughout the home.

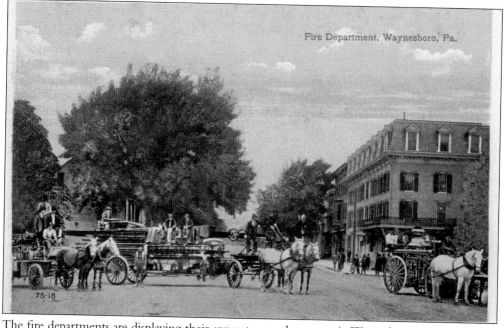

Fire Department, Waynesboro, Pa.

75-18

The fire departments are displaying their apparatus on the square in Waynesboro. Notice that the steam pump and ladders are still being pulled by horses. The two fire companies in continuous existence since the 1880s are the Mechanics Steam and Fire Engine Company and the ATH&L, better known as the Always There Hook and Ladder Company.

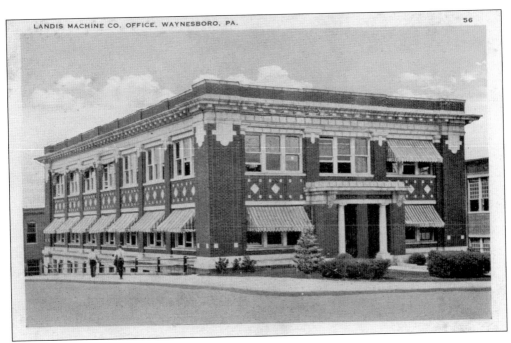

The two Landis brothers, Abraham and Frank, came to Waynesboro seeking employment and found it at the Geiser Manufacturing Company. By 1890, they had opened their own plant, Landis Brothers, so that they could commercialize their inventions. In time, Landis Tool Company became a world leader in precision grinding machines, while Landis Machine Company made thread cutting machines that would thread 90 percent of the allied artillery ammunition during World War II.

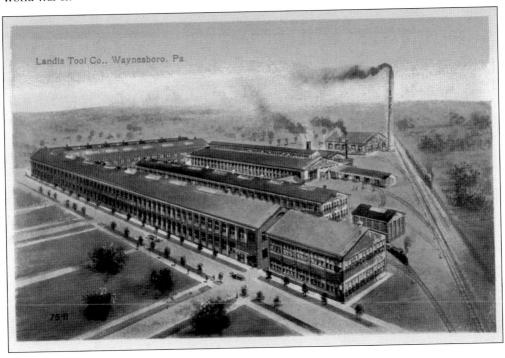

Landis Tool Co., Waynesboro, Pa.

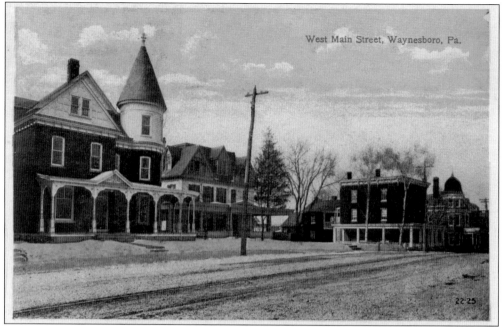

The Queen Ann–style residence on the left is the home of the Waynesboro Historical Society. Joseph Jacob Oller, prominent industrialist, built the house in the 1890s, and his daughter bequeathed it to the historical society in 1992. It is listed on the National Historic Register.

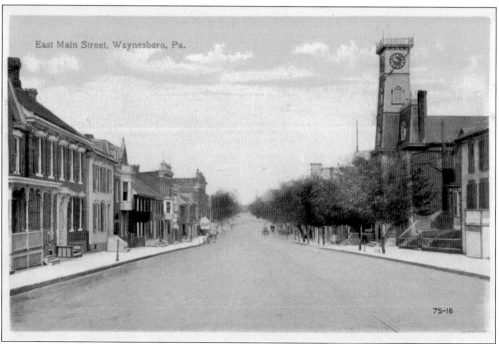

East Main Street in Waynesboro and the clock on top of the town hall are captured in this scene from around the 1890s. The hall served as an academy of music in the 1880s as well as housing two fire companies on the first level. The upper floor later became the town library.

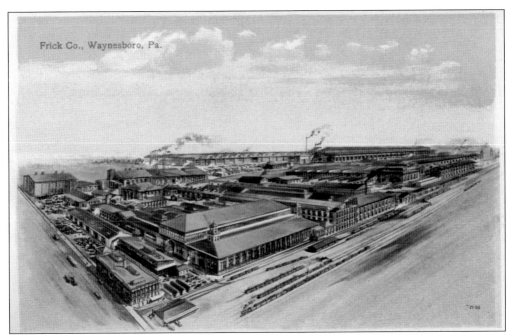

Frick Co., Waynesboro, Pa.

The Frick Company is one of the oldest surviving businesses in Waynesboro. As early as 1852, an advertisement of their services appeared in the *Village Record* newspaper. The company was a pioneer in ice making and refrigeration and also made early steam engines. During the Civil War, Confederates stole the leather belting of the engines to use in repairing shoes.

This church and the two churches on the following page occupy a special place in the religious history of Chambersburg. Founder Col. Benjamin Chambers had originally deeded land for each church (to their trustees) for a modest sum, plus one rose to be paid to him or his heirs annually, forever. To this day, that rose rent is paid to a Chambers descendant on one of the first three Sundays in June. The building shown was constructed in 1803, with the two front towers added in 1868. The stone chapel to its left dates from 1878. The cemetery behind the church contains the remains of many prominent people, including the Chambers family. This land also included an Indian burial ground, for many years visited annually by descendants of local tribes.

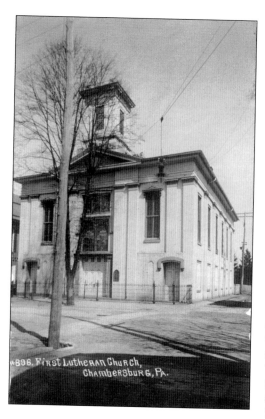

1898. First Lutheran Church,
Chambersburg, PA.

In 1780, Col. Benjamin Chambers deeded land for the Lutheran and Reformed congregations, the Lutherans on West Washington Street and the Reformed on South Main Street, both with the same rental requirement of one rose annually, forever. The two congregations continued to meet in the same log structure until 1808, when a crisis arose over the burial of a Reformed churchgoer who committed suicide, to which the Lutherans strongly objected. The alliance dissolved. The Lutherans remained on Washington Street, building a brick church; the Reformed congregation erected a brick church on South Main Street next to their 1789 schoolhouse.

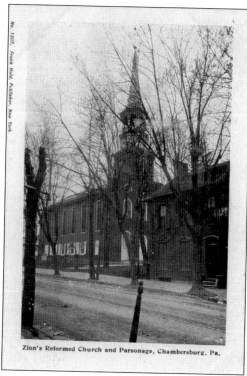

Zion's Reformed Church and Parsonage, Chambersburg, Pa.

As early as 1785, people of the Roman Catholic faith living in Chambersburg were ministered to by traveling clergy. The first Catholic church in Chambersburg was built of logs in 1792. This beautiful stone church was built in 1812. The log church was sold to the African Methodist congregation and moved to Kerrstown, an area in the southern part of Chambersburg, where it stood until 1860.

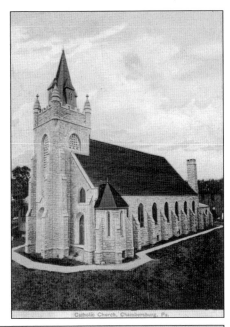

A town hall and market house had been built before 1864. It survived the burning and became the vantage point from which to photograph the ruins of Chambersburg. The story goes that its market was poorly attended and that only the butchers set up stands. Today, it functions as the borough office building, the overhang having been removed. To the right, with its bell on top, is the Friendship Fire Company building that was built before 1911. The caption in the top right of the image is incorrect—Lee marched to Gettysburg in 1863, while destruction of the town took place in 1864.

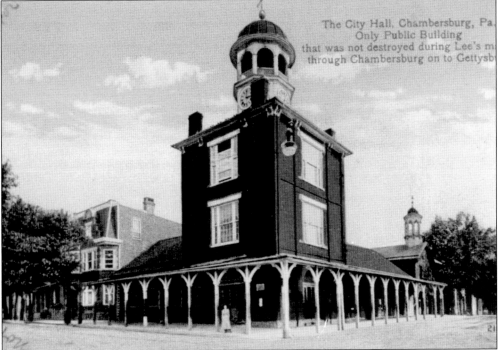

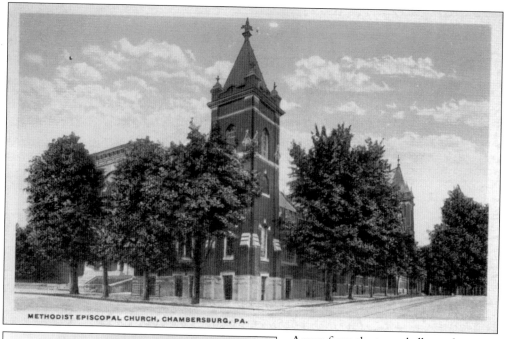

METHODIST EPISCOPAL CHURCH, CHAMBERSBURG, PA.

Across from the town hall stood the Methodist Episcopal church, which survived the burning in 1864. Methodism grew in Chambersburg, despite its initial ostracism, largely due to the "indecent" practice of holding services at night. As early as the 1790s, the Methodists had erected a log meeting house on East Queen Street (east of the present Third Street) with a burial ground adjoining. Built in 1896, this is the third church built on that site—the corner of Queen and Second Streets. It was destroyed by an arsonist in 1995.

Next to where the Methodist Episcopal Church stood is the Masonic Temple on South Second Street. It was built between 1823 and 1824 by Silas Harry and is on the Historic Register as the oldest building in Pennsylvania to have been erected solely for use as a Masonic lodge. This building was also spared during the burning. It is claimed the Confederate soldier charged with firing the building was also a Mason and refused to destroy it. This photograph was taken before the remodeling project of 1897.

This postcard from 1915 shows the front of Second Lutheran Church, which was established because First Lutheran Church had changed its language to English to satisfy the younger members of the congregation. The older members, who spoke only German, had withdrawn and were meeting in the Masonic Hall on Second Street until they had funds to build this church in 1839. Their new constitution barred the use of the English language forever; any minister attempting to use English would forfeit his office. This constitution was read aloud each Easter Sunday for many years.

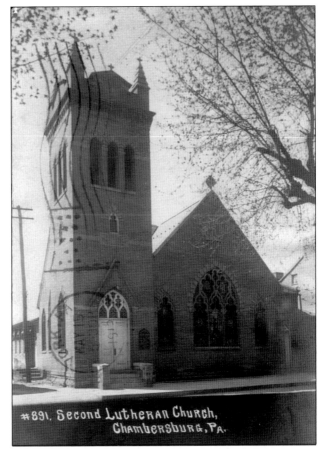

#891. Second Lutheran Church, Chambersburg, Pa.

Looking west on King Street near the intersection with Main Street is an unfinished bridge near to where the Falling Spring meets the Conococheague Creek a short distance to the south. It may have been used as a fishing hole in the early years of the new century.

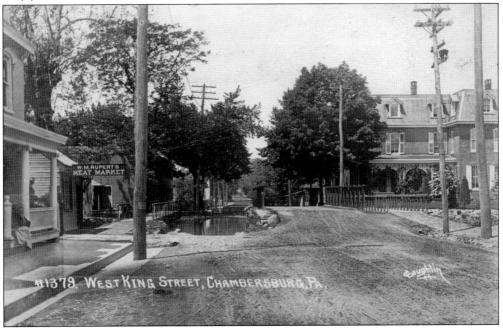

#1379. West King Street, Chambersburg, Pa.

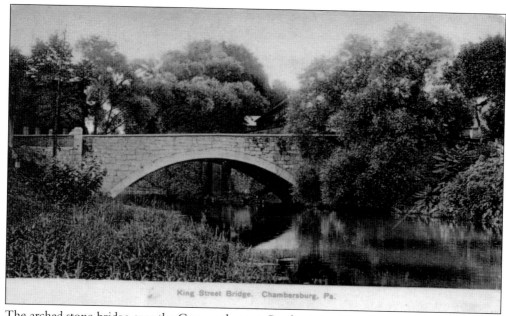

King Street Bridge, Chambersburg, Pa.

The arched stone bridge over the Conococheague Creek at West King Street was built by Silas Harry in 1828. Harry was a well-known mason and contractor who built the 1842 courthouse, the previously mentioned Masonic Temple, and other bridges in the county. He lived in the old stone house on the east side of South Main Street near Liberty Street—a house that stands today.

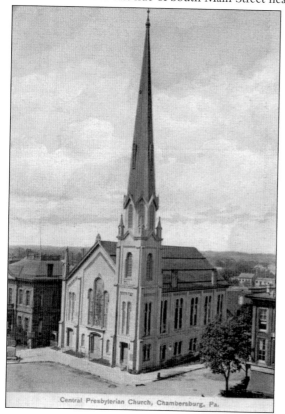

Central Presbyterian Church, Chambersburg, Pa.

The Falling Spring Presbyterian Church had become so overcrowded by 1860 that few families could obtain pews. A second congregation was formed and a new location found on the southwest corner of the Diamond, the property given to the congregation by Colonel James Austin. Sarah Wilson, whose money would establish Wilson College, also gave freely to the building, including the money to build a planned spire 186 feet high. When some members disapproved and rebuked her, she stuck to her guns and said, "If the Lord does not want it there, He will knock it down." It still stands today.

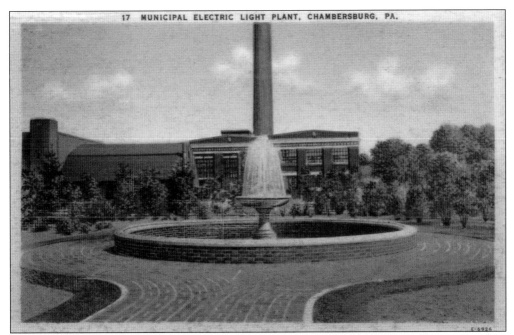

The fountain and its surrounding area on North Second Street are known as the Park of the Valiant. The site commemorates the actions of James Cree, John Hoke, Joshua Sharpe, and Matthew Strealy. In the face of public opposition, they prevented the sale of the borough's electric light plant (in the background). J. Hase Mowrey purchased the decorative fountain from the General Electric Company for $1,400. (Courtesy of Kris Greenawalt.)

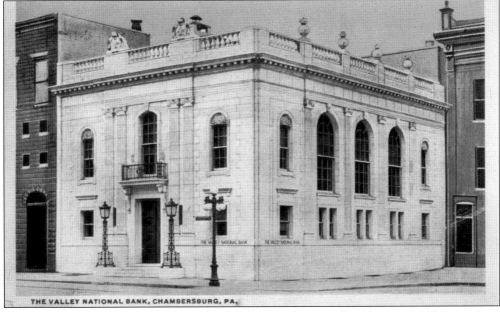

THE VALLEY NATIONAL BANK, CHAMBERSBURG, PA.

Today, this building is known as "the marble building on the square" and houses the Chambersburg Heritage Center. An elaborate neoclassical building, it was designed by Frank Furness in 1916 for the Valley National Bank. Furness was a decorated Civil War soldier who became the noted architect of many museums and schools.

While the United Brethren denomination had been represented in Franklin County since the early 1800s, the church in this postcard was built during 1899 and 1900, with services held in the Rosedale Theater during the construction period. Many additions and changes have been made during the years, and today the building houses the First United Methodist Church.

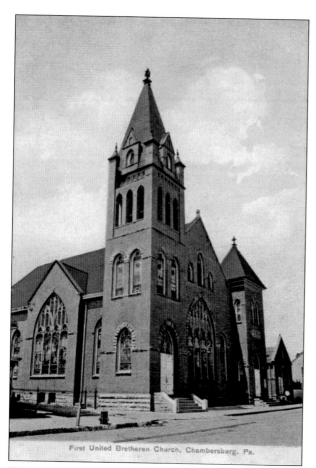

First United Bretheren Church, Chambersburg, Pa.

Chambersburg's new federal building opened in 1912 to serve as the post office. It is considered classical in style and was made of pressed white brick and Indiana limestone. Terracotta was used in the decorative work. It functioned as the post office until 1962, and today houses the Coyle Free Library.

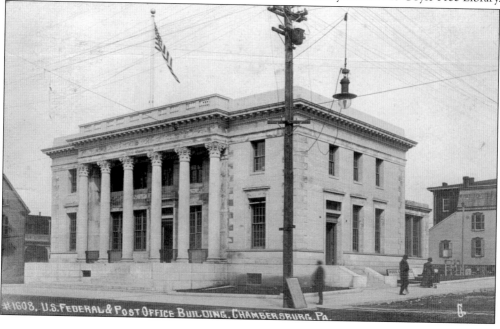

#1608. U.S. FEDERAL & POST OFFICE BUILDING, CHAMBERSBURG, PA.

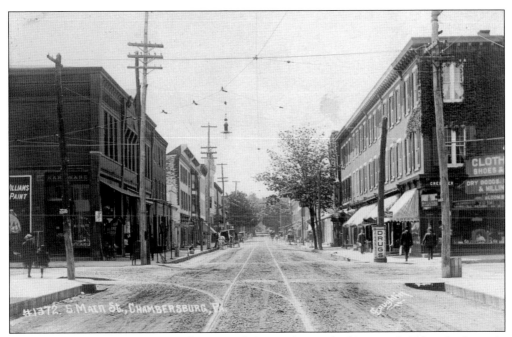

This view is of the intersection of Main and Queen Streets, looking south. Taken in the early 1900s, one can see the trolley tracks and the sign on the hardware store—Sherwin Williams Paint. Early electric lights are hanging above the intersection. Notice the "horse" in the door of the hardware store.

John Brown boarded at this house in Chambersburg during the summer of 1859 while planning his raid on Harpers Ferry, Virginia. Using the alias Isaac Smith, he was held in high regard by the local townsfolk who thought him to be either a minister or a businessman developing iron mines. On the National Historic Register, this historic site is owned and operated by Franklin County Historical Society–Kittochtinny (formerly Kittochtinny Historical Society).

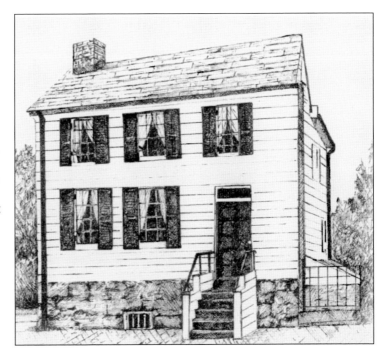

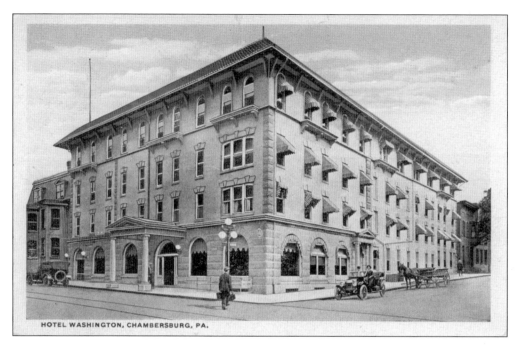

HOTEL WASHINGTON, CHAMBERSBURG, PA.

A Chambersburg landmark, the Hotel Washington on the corner of Lincoln Way East and Second Streets had once housed the most famous dining room and elaborate sleeping accommodations in the Cumberland Valley, catering to such notables as Henry Ford, Andrew Mellon, and Babe Ruth. Built sometime after the Civil War, it was the leading hotel in the town, employing 200 people in its heyday. It functioned on the "European plan," as advertised in its brochure, and was considered comparable to the Ritz-Carlton of Philadelphia and the Chalfonte in Atlantic City. The coming of motels caused its decline, and it was razed in the 1980s. It is now a parking lot.

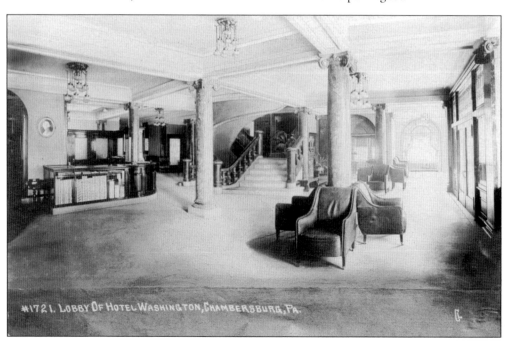

#1721. LOBBY OF HOTEL WASHINGTON, CHAMBERSBURG, PA.

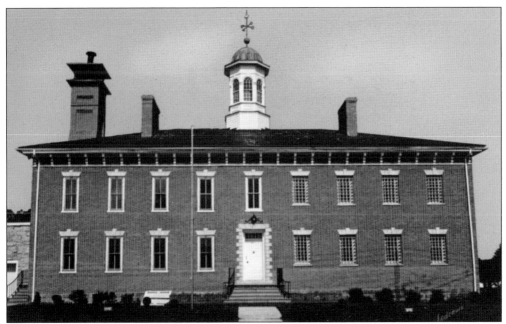

This Georgian building in Chambersburg was erected in 1818 to serve as a county jail. Its particular intention was to prevent prisoners from escaping as they were from jails in adjacent counties. It served its purpose for 158 years, finally closing in 1970. At that time, it was saved from destruction by a group of devoted local historians who then restored it. It is maintained as a historic site, functioning as the home of Franklin County Historical Society and as a museum.

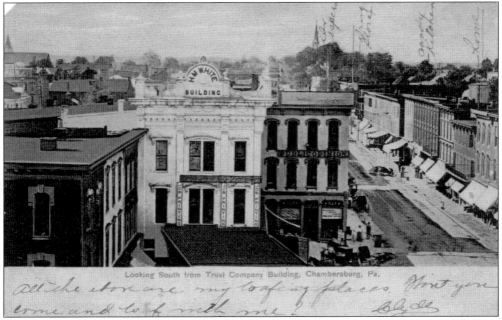

Looking south from the Diamond in 1907, this postcard view shows the White Printing Office. The writer, Clyde, identifies various buildings on Main Street including his home, the Olympia Candy Kitchen (which celebrated its 100th anniversary in 2003), and the drug stores. Perhaps they had some meaning to Anna Gouff, to whom this card is addressed. (Courtesy of Adda Higgens.)

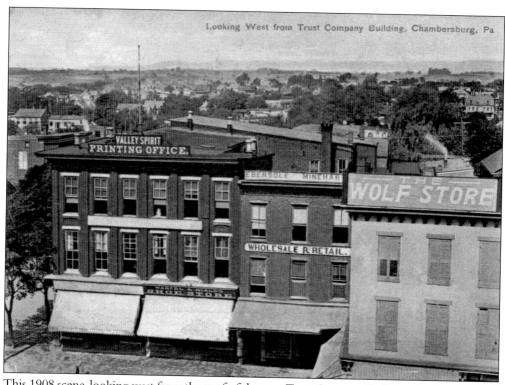

VALLEY SPIRIT
PRINTING OFFICE.

EBERSOLE MINEHAR

WOLF STORE

WHOLESALE R. RETAIL.

This 1908 scene, looking west from the roof of the new Trust Company building in the Diamond, shows the *Valley Spirit* newspaper office, which was in competition with various other newspapers of the time—the *Public Opinion*, the *Franklin Repository*, and the *Peoples Register*. The Wolf Store was connected with the Wolf Company and sold fine women's and men's clothing.

The cornerstone of this church was laid in 1891 after the expansion of homes in the north end of Chambersburg produced a need for still another Lutheran church in the borough. In 1929, the entire church was moved by Hafer Construction Company to the rear of the lot, and a stone addition was built in front. In the first decades of the 1900s, moving structures was a regular event.

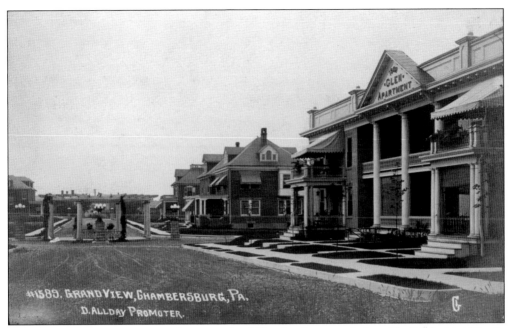

The first planned development in the Borough of Chambersburg was designed by Diederick Allday in 1909. The central street, with its fountain and pergola, was appropriately named Grandview. According to newspaper records, at the outbreak of World War I, such hatred existed for anything German that fires were lit in front of Allday's home, his flag was torn down, and he was burned in effigy on the square. He lost his wealth in the stock market crash of 1929 and died destitute in 1951.

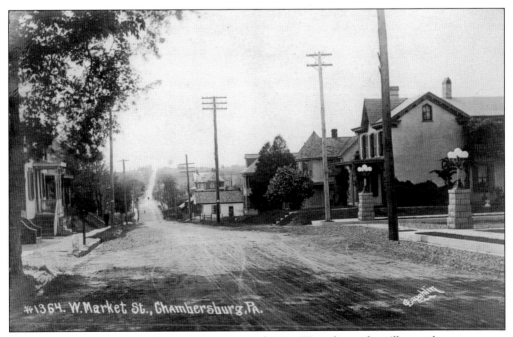

This early view of West Market Street, now Lincoln Way West, shows the pillars at the entrance to Grandview. The photograph, taken approximately 100 years ago, shows an unpaved highway but paved sidewalks. Except for the dirt street, it looks basically the same today.

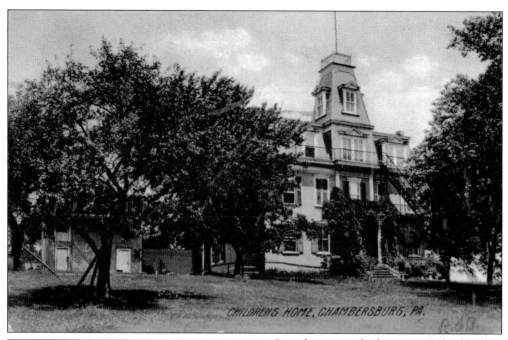

CHILDRENS HOME, CHAMBERSBURG, PA.

Take Care of Me Now . . .
I Can Help Myself Later!

* * *

Why does Franklin County Need Its
Children's Aid Society?

Once known as the home on Federal Hill, in 1887 this building became the third home of the Children's Aid Society. During the burning of Chambersburg, the house was saved from destruction by the Confederate colonel Harry Gilmore. He knew that it was the home of Union colonel William Boyd, who had been kind to the civilians in the valley of Virginia during Gen. David Hunter's campaign. In 1976, the house was razed to make way for a one-story building more appropriate for housing children.

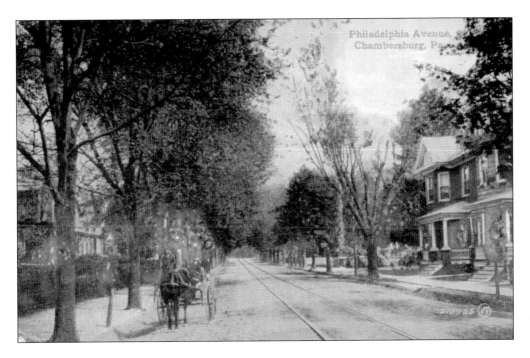

"On the Avenues"—Philadelphia and Fifth—refers to two of the most beautiful tree-lined streets in Chambersburg. The large homes were built there by many of the prominent businessmen of the late Victorian age. The trolley tracks are still visible on the Philadelphia Avenue postcard, and the pillars of the maternity home can be seen on the left side of the Fifth Avenue postcard. While these postcards date from a period prior to 1920, the homes can be easily identified today as one drives by.

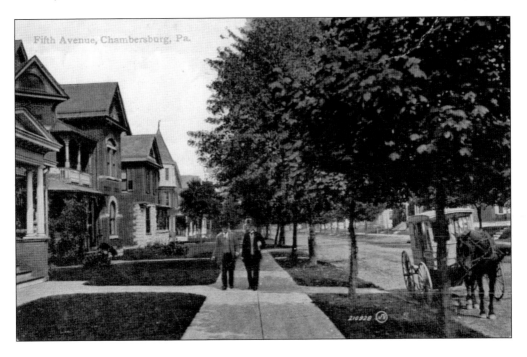

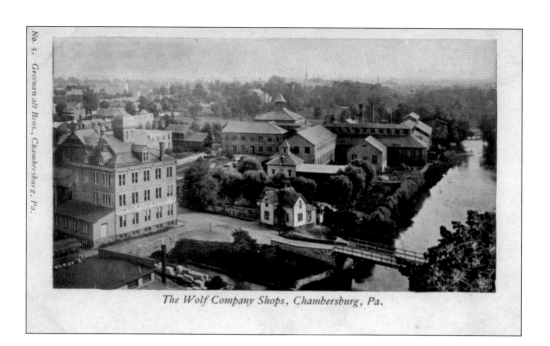

The Wolf Company Shops, Chambersburg, Pa.

In 1884, Augustus Wolf moved his business to Chambersburg from Allentown, Pennsylvania. The company manufactured flour-milling machinery and was one of the oldest and largest such firms in the United States. In time, they built an international reputation, and in 1915, they were awarded the grand prize for machinery at the Panama-Pacific International Exposition. They were also one of the first local businesses to employ women. After World War II, the company went out of business, and in 1950, it was sold and the buildings converted for storage use.

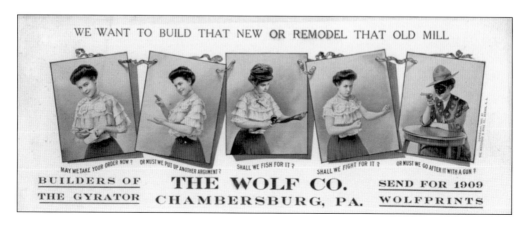

WE WANT TO BUILD THAT NEW OR REMODEL THAT OLD MILL

MAY WE TAKE YOUR ORDER NOW ? OR MUST WE PUT UP ANOTHER ARGUMENT ? SHALL WE FISH FOR IT ? SHALL WE FIGHT FOR IT ? OR MUST WE GO AFTER IT WITH A GUN ?

BUILDERS OF THE GYRATOR THE WOLF CO. CHAMBERSBURG, PA. SEND FOR 1909 WOLFPRINTS

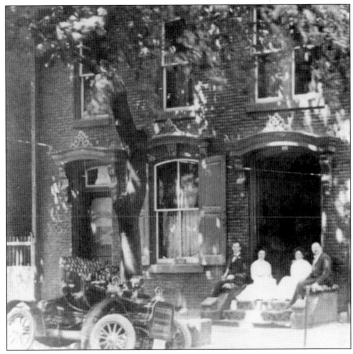

The Chambersburg Hospital was founded by the Hospital Department of the Children's Aid Society. In the above photograph, the first building to be used as a private hospital beginning in 1895 still stands on South Main Street where generations of the well known Senseny family of physicians practiced medicine. Supposedly a bullet hole in the French door is a reminder of when the town was invaded by Confederates. Below, the hospital building on the postcard was finished and opened in 1905. The first patient was 10-year-old Johnny Krout, who had been stabbed attempting to save his sister from an attacker. (Above, courtesy of Chambersburg Hospital.)

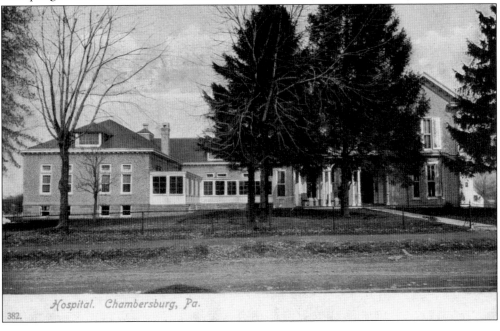

"Greetings from Chambersburg" is written on the front of this postcard, but on the back is a message that sounds very different: "I received your card. Good by [*sic*] from Ruth." Perhaps this was the breakup of a love affair?

John Lindsay Christian wrote this poem of 89 verses, *The Queen City of the Cumberland Valley in Poetry* in 1947, which recounts the history of Chambersburg. As a musical composer, he wrote *Song of the Conococheague*, among other compositions that were in music stores in some of the larger cities. Christian came from an African American family whose parents were slaves in Virginia and who settled in Chambersburg after the Civil War.

CHAMBERSBURG
PENNSYLVANIA

The Queen City
of the
Cumberland Valley
in Poetry

by
JOHN LINDSAY CHRISTIAN

Three

CONFEDERATE INVASION

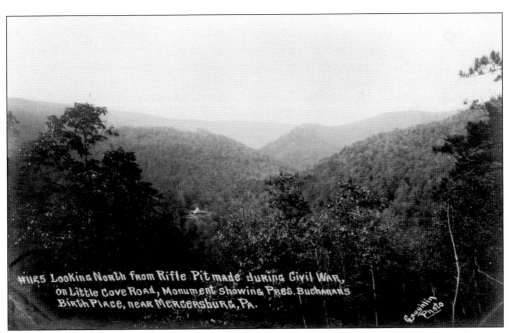

#1125 Looking North from Rifle Pit made during Civil War, on Little Cove Road, Monument showing Pres. Buchanans Birth Place, near Mercersburg, Pa.

President Buchanan's birthplace was photographed from this Civil War rifle pit on Little Cove Road. Similar to what soldiers call a foxhole, a rifle pit was a shallow trench that sheltered soldiers against attack. They were generally three or four feet deep and mounded up at the end for protection against enemy fire.

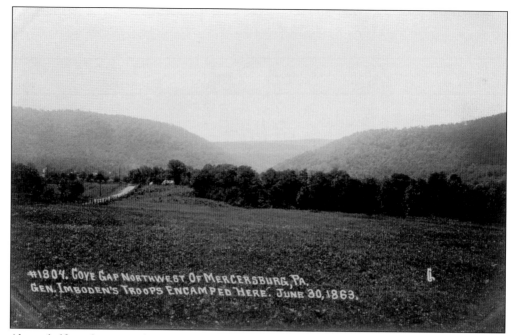

#1804. COVE GAP NORTHWEST OF MERCERSBURG, PA. GEN. IMBODEN'S TROOPS ENCAMPED HERE. JUNE 30, 1863.

About halfway between the towns of Mercersburg and Cove Gap, Confederate general John Imboden established camp here on June 30, 1863. He had been ordered to guard the roads for the divisions of Gen. William Jones and Gen. Beverly Robertson, who were guarding the rear of Gen. Edward Johnson's division and Gen. Richard Ewells's wagon train. All of these men would be gathered in Gettysburg only a few days later.

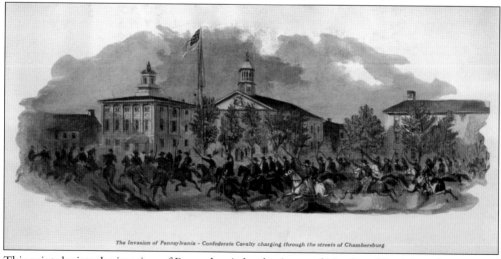

The Invasion of Pennsylvania - Confederate Cavalry charging through the streets of Chambersburg

This print depicts the invasion of Pennsylvania by the Army of Northern Virginia as they entered the Diamond in Chambersburg. The courthouse and Franklin Hall are in the background. During the third week of June 1863, the Confederates "streamed through our streets, long columns of infantry and artillery, accompanied by immense trains of wagons and cattle," writes Jacob Hoke in *Reminiscences of the War*.

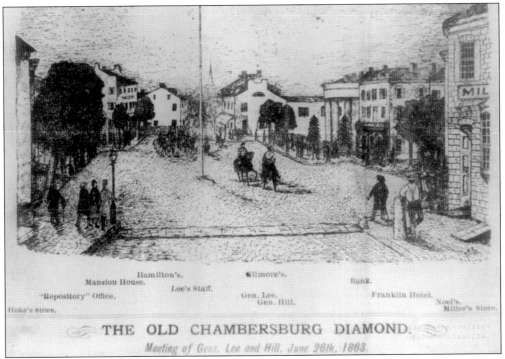

THE OLD CHAMBERSBURG DIAMOND.

Meeting of Gens. Lee and Hill, June 26th, 1863.

Friday, June 26, 1863, Gen. Ambrose Hill, already in Chambersburg, anxiously awaited the arrival of General Lee and his staff, who were coming up from the south. According to Jacob Hoke, Lee and Hill rode a distance apart from the others. Hill then pointed eastward to the road leading to Gettysburg and fell back, allowing Lee to go in advance. Reaching the middle of the Diamond, Lee turned his horse's head eastward and was followed by his staff. The decision had been made.

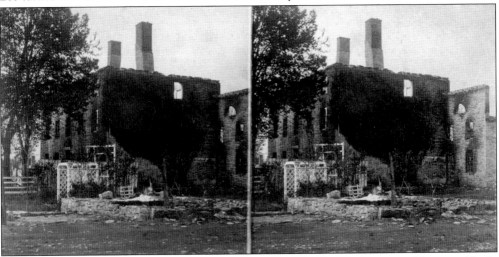

July 30, 1864, proved to be a horrific day in the annals of Chambersburg. In one fell swoop, blocks of homes were destroyed by the great fire ordered by Gen. John McCausland. This stereoscopic card was taken immediately after the burning. It shows the ruins of the Rosedale Seminary for Young Ladies on North Main Street. It had previously been the three-story stone dwelling of Capt. Benjamin Chambers, son of the town's founder; a path of roses leading to the house gave it the name Rosedale.

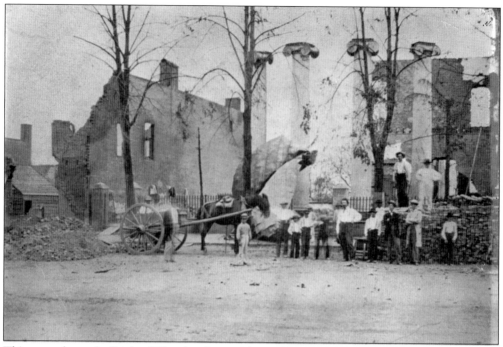

This scene shows the Bank of Chambersburg with its pillars still standing, and to its left the remains of what was known as the Gilmore building. The Gilmores were prominent people in the town—William was appointed postmaster and elected sheriff. Later generations of this family established the Gilmore-Hoerner Foundation.

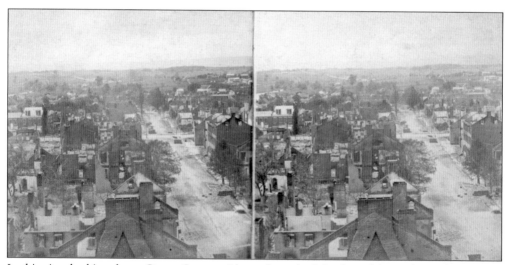

In this view looking down Queen Street, midway along the left edge of the card are two attached houses that were left untouched by the burning, as well as two more adjacent to them. One other house on West Market Street (Lincoln Way West) was saved. Two elderly sisters lived there and knew that their house would not be burned because they had a document called, "A True and Tried Art Which May Be Successfully Used in Times of Fire and Pestilence." The document read, "Whoever has this paper in their house, will not suffer from fire, nor from damage by lightning; and whoever has this paper in their house, or carries it with him, is safe from the fearful Pestilence."

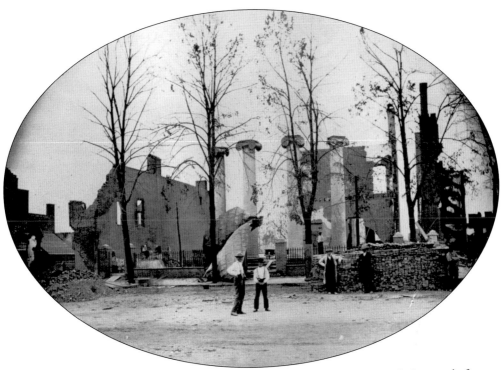

Another view of the Bank of Chambersburg is shown "as McCausland left it." The year before, on his march to Gettysburg, General Lee issued in Chambersburg his General Order Number 73 that required troops to abstain from any unnecessary or wanton injury to private property.

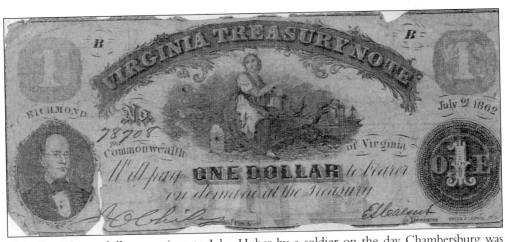

This Confederate dollar was given to John Huber by a soldier on the day Chambersburg was burned. It was payment for hardware bought that day at Huber's store, located on the southeast corner of Main and Queen Streets. The store was one of the many buildings destroyed in the fire.

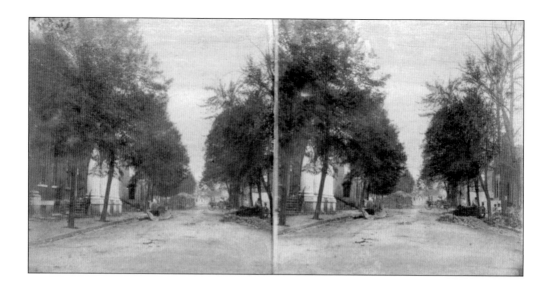

These two views of the aftermath of the burning of the courthouse and East Market Street were taken from different angles. The courthouse was fired with two or three barrels of kerosene taken from the neighboring grocery. Jacob Hoke wrote, "When we passed it the flames were rolling up the stairway and bursting out of the door and windows of the west end." The card above, shot looking east, shows the standing pillars fronting on Market Street, while the card below shows the ruins of buildings. In the first card, one can see smoke still coming from the window in the building adjacent to the courthouse, and in the second card, smoke is coming from the building's upper window on the right.

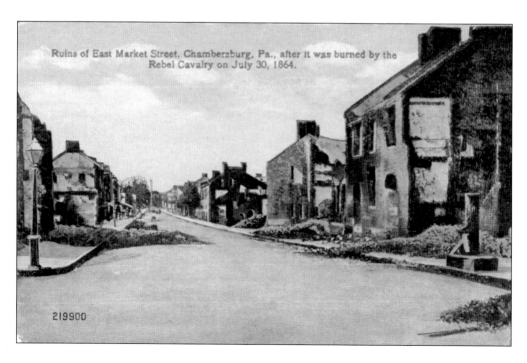

Ruins of East Market Street, Chambersburg, Pa., after it was burned by the Rebel Cavalry on July 30, 1864.

219900

74

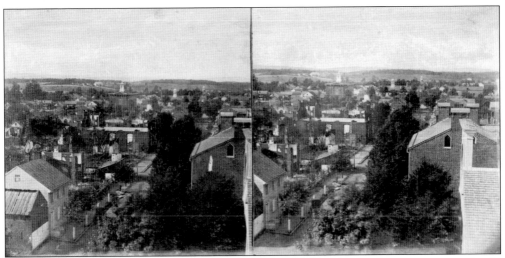

Rising from the ashes like the Phoenix, Chambersburg began the process of rebuilding immediately. The card above shows the view from the market house at the corner of Queen and South Second Streets looking north. In the center background, one can see the cupola of King Street School Hospital and to the right, the cupola of the "Old Jail." Both buildings survived the burning. The card below shows the rebuilding on the third floor of Brandt's Hotel, from the market house looking west. This site is the stone building on the northwest corner of Queen and Second Streets.

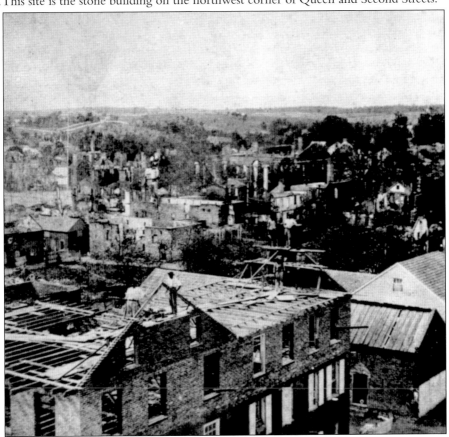

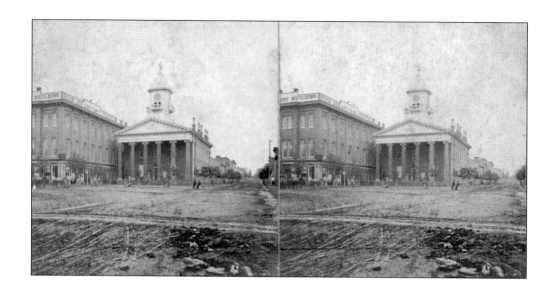

This photograph of the Diamond in the center of Chambersburg was taken before the fountain was installed, sometime between 1864 and 1878. The courthouse with Benjamin Franklin atop it and the Franklin Repository building to its left were rebuilt immediately after the fire. The photograph below, dating before 1890, is a partial view of the fountain as dedicated in 1878, including the cannon and the statue of a Union soldier facing south to guard against the return of Southern raiders. According to tradition, a descendent of founder Benjamin Chambers had jokingly suggested: "Put him on the south so he can let us know if the rebels are coming again."

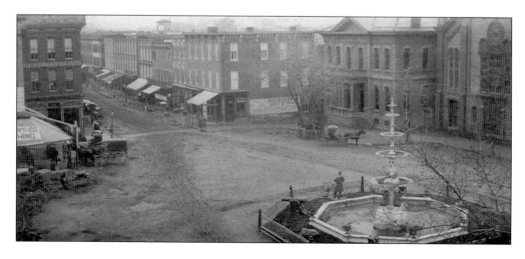

Four

EDUCATION

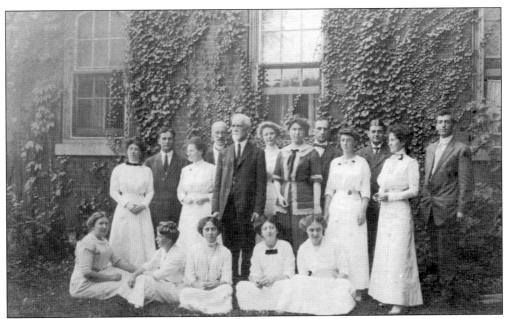

Wilson Female College faculty is posed for an event sometime around the turn of the 20th century. Presumably, the elderly gentleman in the center is the Rev. Samuel Martin, D.D., president of the college between 1895 and 1903. Martin was responsible for the founding of the Kittochtinny Historical Society in 1898, when a group of leading local men from various backgrounds were invited to meet at his home on the college grounds to discuss forming such an organization.

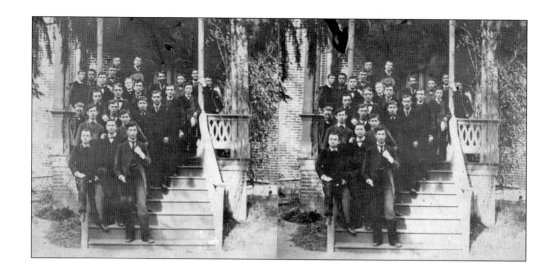

In 1796, Capt. Benjamin Chambers, son of the founder of Chambersburg, deeded ground on the corner of Queen and Third Streets for educational purposes only. The Chambersburg Academy, a private school for boys, opened there by 1800. It was used as a hospital during the Civil War and burned by the Confederates in 1864. It was rebuilt in 1868, and this postcard from the early 1900s shows a group of students standing on the front steps. In 1909, it was razed to allow for a new, more modern building, shown in the next postcard.

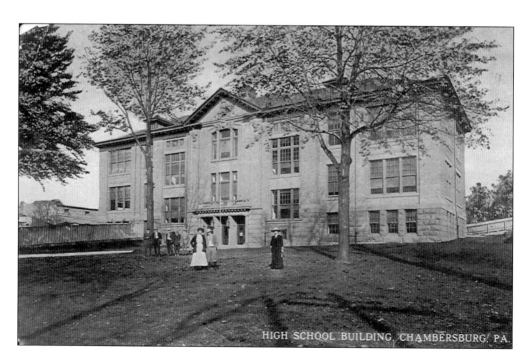

HIGH SCHOOL BUILDING, CHAMBERSBURG, PA.

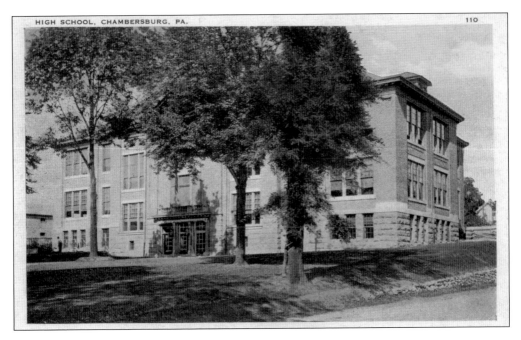

The new high school, above, was constructed for approximately $58,000. The gymnasium was located on the third floor and the study hall on the second floor. In 1931, the building was extended in the front to Queen Street, creating space for a center staircase and an auditorium seating 600 to 700 people. It later became Central Junior High School when the new Senior High School, below, was built in 1955 on the corner of Sixth and McKinley Streets for $3,265,000. While this building sufficed for many years, it has been recently renovated and expanded to accommodate our ever-growing student population.

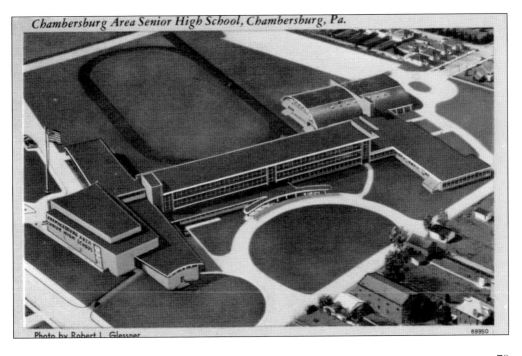

Chambersburg Area Senior High School, Chambersburg, Pa.

Photo by Robert L. Glessner 89950

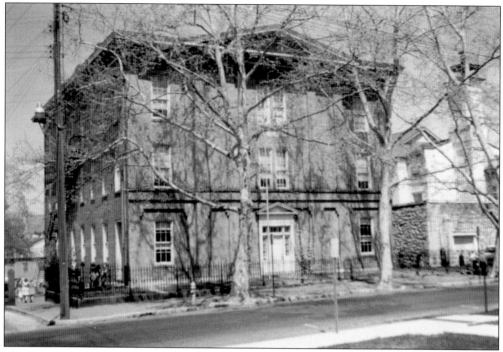

The King Street School was built in 1857 after negotiations on the part of the school board to buy the land next to the jail. Over the next century, the building was used to house schoolchildren, as a hospital for both Union and Confederate troops during the Civil War, and as a center for the Franklin County rationing board during World War II. It was razed in 1962 to make way for a more modern school building.

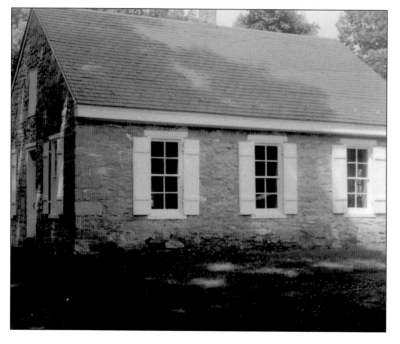

This stone structure is the Brown's Mill Schoolhouse built in 1834 in the area known as Brown's Mill. It was named for two brothers, George and Thomas Brown, who were granted a patent in the 1700s for a vast tract of land. Today, the schoolhouse is owned and operated by Franklin County Historical Society–Kittochtinny and opens each summer for tours. It was listed on the Historic Register in 1973.

Ground-breaking ceremonies for the Mercersburg Chapel took place in June 1922 and included an address by Vice Pres. Calvin Coolidge, whose sons attended the academy. Approaching Mercersburg, one can see the spire rising 160 feet in the air. Designed as a replica of St. Mary's spire in Oxford, England, it is topped with an eight-foot gold cross that is lighted at night.

The interior of the chapel illustrates the English Gothic influence in its clerestory windows, pointed arches, and wood hammer-beams. The wrought iron pulpit was built so as to be removable for large gatherings. A carillon in the belfry contains 43 bells cast in England, 20 of the largest bearing names. On one of the bells, 223 pieces of molded copper were inset representing coins from around the world.

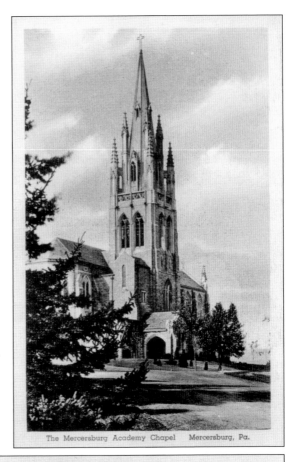

The Mercersburg Academy Chapel Mercersburg, Pa.

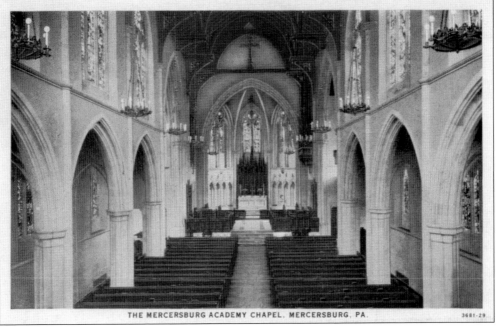

THE MERCERSBURG ACADEMY CHAPEL, MERCERSBURG, PA. 3681-29

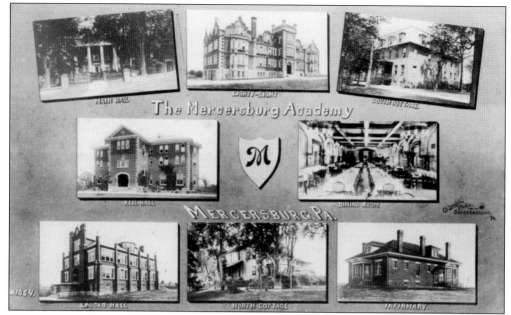

Mercersburg Academy, located in the town of Mercersburg, was originally founded as a college and theological seminary. By 1871, both college and seminary had moved to Lancaster, becoming Franklin and Marshall College. After several more transformations, Mercersburg Academy emerged in 1893. Famous academy students have included the sons of Pres. Calvin Coolidge and actors James Stewart and Benicio del Toro.

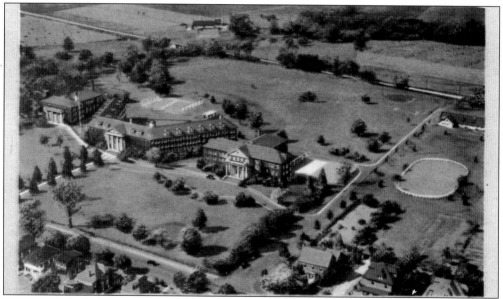

Penn Hall Preparatory School and Junior College was formed in 1906 when the board of directors at Wilson College voted to discontinue their own preparatory school, and three members felt that the need to prepare women for college should still be addressed. Each May from 1913 to 1942, the entire school spent time at the seashore in Atlantic City, where classes were conducted from the Hotel Flanders. These annual excursions ended when the Army took possession of the hotel. Today the school is part of the Menno Haven retirement community.

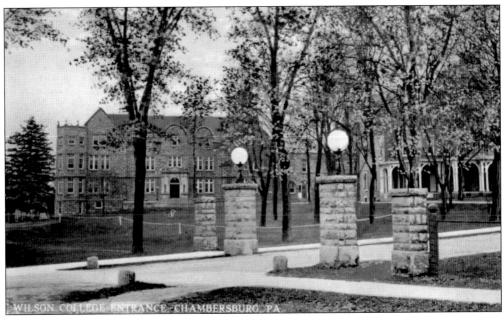

WILSON COLLEGE ENTRANCE, CHAMBERSBURG, PA.

Wilson College was founded in 1869 "to extend to young ladies the same high advantages for a thorough education as now afforded to young men in the best colleges in the land." A subscription appeal went out to all the towns in Franklin County to determine the location of the new school, and Chambersburg won with a pledge of $23,000. Sarah Wilson, of the town of St. Thomas, was the principal donor, and the school was named in her honor. Subsequently, Col. Alexander McClure's estate in the north end of town—including the elegant mansion known as Norland—was procured. Norland Hall became the main building, and with its extensions housed a dining room, chapel, dormitories, study parlors, and on the fourth floor, a piano practice room and an art room. Today, Wilson College stands at the forefront of women's education.

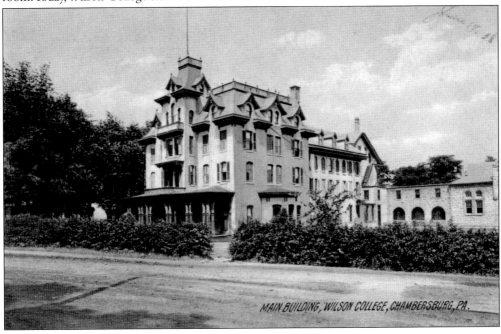

MAIN BUILDING, WILSON COLLEGE, CHAMBERSBURG, PA.

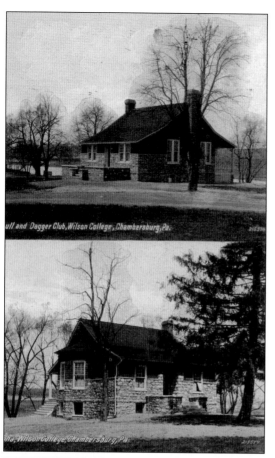

The two buildings in this 1913 postcard were the clubhouses for the Wilson College secret societies, Scull and Dagger and Aloha, and are no longer standing. In 1946, after World War II, about 23 men used the GI Bill to attend Wilson College for one year. The Scull and Dagger clubhouse was used by the young men for studying and also for some legendary poker games.

The library on the campus of Wilson College was named for John Stewart, a prominent attorney and judge in Franklin County. He would have been named chief justice of the state court if he hadn't been tragically killed on Thanksgiving Day, 1920. He was crossing Philadelphia Avenue to have dinner with his sister when struck by the Chambersburg and Gettysburg trolley car.

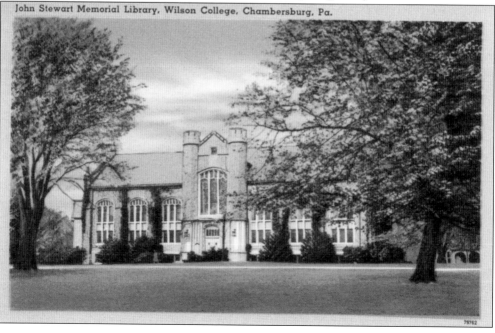

John Stewart Memorial Library, Wilson College, Chambersburg, Pa.

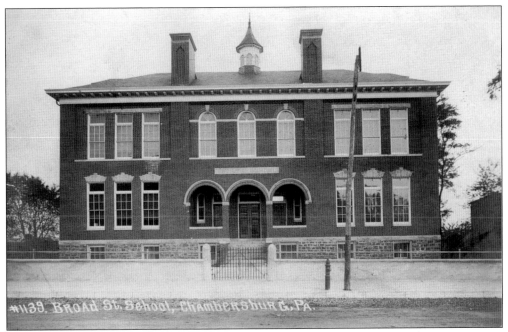

Broad Street School opened in 1908, but within several years, additions were needed because of the growth and development of the north end of Chambersburg. In 1933, the school directors passed a resolution changing the name of the school to Mary B. Sharpe in memory of a much-loved local resident who had given generously to the community and the school before meeting an untimely and tragic death.

This postcard shows Pennsylvania State University Mont Alto campus. The school was founded as Pennsylvania State Forest Academy in Mont Alto in 1903. It joined Pennsylvania State University in 1929 as part of the forestry school. It became a commonwealth campus in 1963, offering the first two years of college to 180 Penn State students. It went coed the same year.

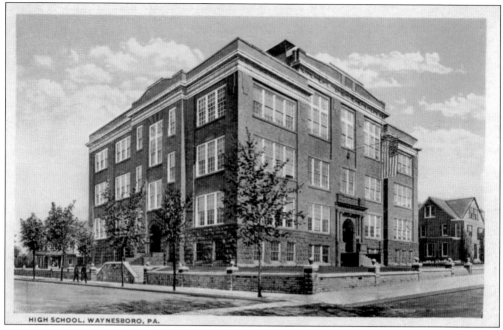

HIGH SCHOOL, WAYNESBORO, PA.

The Waynesboro High School was built in 1909, the building later becoming the junior high school. During the 1930s, Charles (Rip) Engle was hired to teach math and coach football. His teams were so successful that he moved on to Brown University. There he met a student, Joe Paterno, who would follow him to Pennsylvania State University and become his assistant coach. The rest is history.

Five

TRANSPORTATION

Having started from Harrisburg, seven cars of the Cumberland Valley Railroad arrived in Chambersburg on November 16, 1837, to great fanfare. The station was located on North Second Street beyond the Falling Spring Creek. The first train was met by thousands, and a sumptuous banquet was prepared at Culbertson's Hotel (on the Diamond) for the notables, including Thaddeus Stevens, attending. This notice of January 25, 1838, gives the train's first timetable.

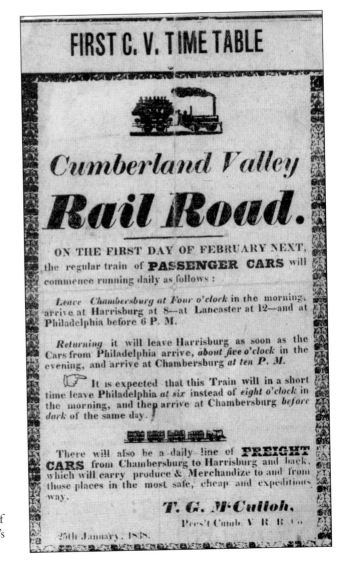

FIRST C. V. TIME TABLE

Cumberland Valley
Rail Road.

ON THE FIRST DAY OF FEBRUARY NEXT, the regular train of **PASSENGER CARS** will commence running daily as follows :

Leave Chambersburg at Four o'clock in the morning, arrive at Harrisburg at 8—at Lancaster at 12—and at Philadelphia before 6 P. M.

Returning it will leave Harrisburg as soon as the Cars from Philadelphia arrive, *about five o'clock* in the evening, and arrive at Chambersburg *at ten P. M.*

☞ It is expected that this Train will in a short time leave Philadelphia *at six* instead of *eight o'clock* in the morning, and then arrive at Chambersburg *before dark* of the same day.

There will also be a daily line of **FREIGHT CARS** from Chambersburg to Harrisburg and back, which will carry produce & Merchandize to and from those places in the most safe, cheap and expeditious way.

T. G. M'Culloh,

Pres't Cumb. V R R Co

25th January, 1838.

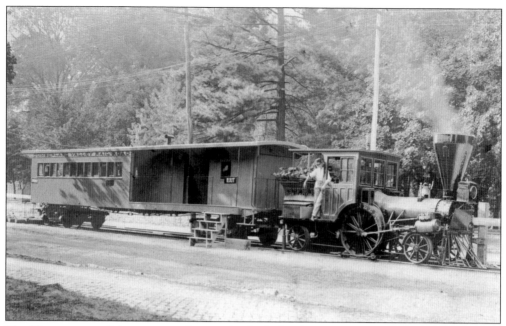

The Pioneer was a light passenger locomotive built for the Cumberland Valley Railroad. It was strong enough to pull three or four cars at 40 miles per hour. It served the passenger service from 1851 to 1876 and was then employed until 1909 in the construction service. Although partially damaged by the Confederates in 1862, it was repaired and made its last run in 1900. In 1919, it was conveyed to the Smithsonian Institution. These two cards (from the Boyd family) show it in 1909 when it was on exhibition in Chambersburg. Gen. J. Fulton Boyd was the railroad superintendent after the Civil War and settled in Chambersburg with his family.

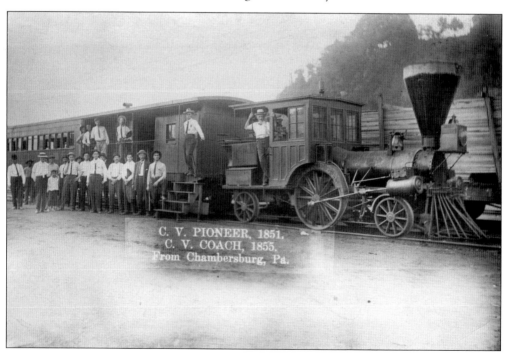

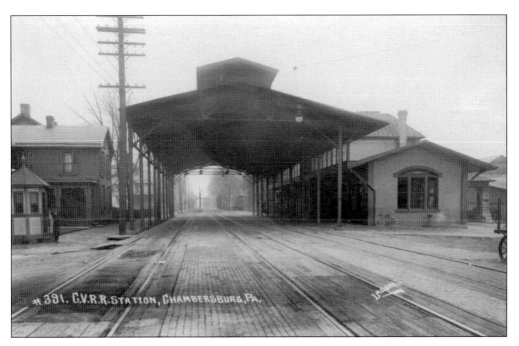

The Cumberland Valley Depot, on the corner of Third and King Streets, was in operation from 1876 to 1914 and was the second building to serve as the Cumberland Valley Railroad's Chambersburg station. In the 1880s, a car was built at the railroad's shops. It contained a steam engine that turned a dynamo, generating enough light to play nighttime baseball—one of the earliest such attempts in the nation. The game was played in a field between Third and Fourth Streets. The building to the right on the postcard above now houses the *Public Opinion* newspaper. (Bottom, courtesy of Kris Greenawalt.)

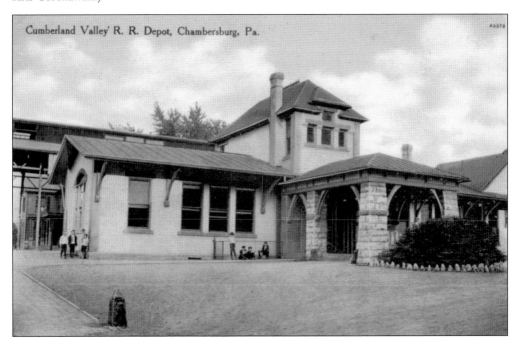

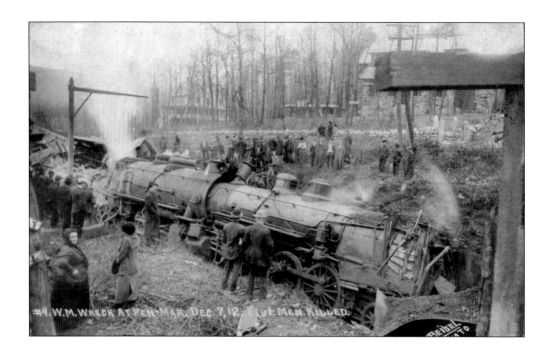

#4. W.M. WRECK AT PEN-MAR, DEC. 7, 12. FIVE MEN KILLED.

Railroad accidents were fairly frequent. Within two months of each other, an accident took place north of Chambersburg and another at Pen Mar. In the latter, five men were killed—mostly employees, not passengers. The back of the card below reads, "This was a terrible wreck. I suppose you read of it in the *Opinion*."

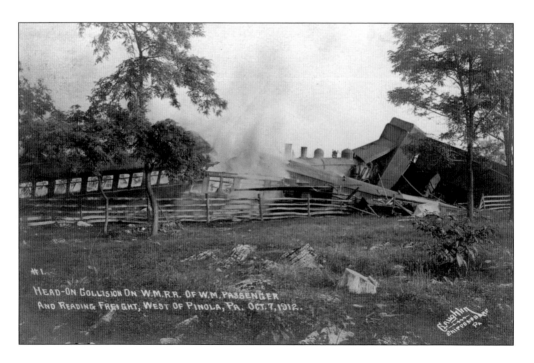

#1.
HEAD-ON COLLISION ON W.M.R.R. OF W.M. PASSENGER
AND READING FREIGHT, WEST OF PINOLA, PA. OCT. 7, 1912.

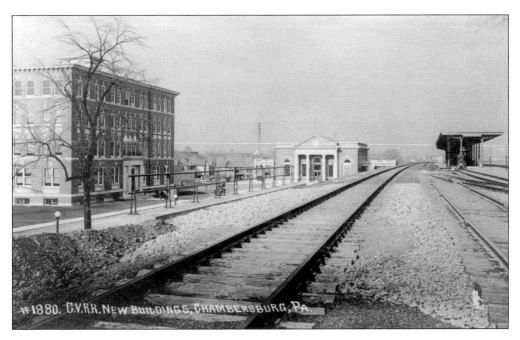

#1880. C.V.R.R. NEW BUILDINGS, CHAMBERSBURG, PA.

In the early 1900s, trains were passing through towns every 20 minutes, which was both disruptive and dangerous. The need to build "high lines" was obvious, but for several years this idea ran into public opposition because it required running lines through quiet residential areas. Finally, after an agreement was reached with the Borough of Chambersburg, the lines were installed with immigrant labor—Italians, Slavs, and Romanians. The new Cumberland Valley Railroad offices, passenger station, and train shed were completed in 1914, the third station in Chambersburg. The passenger station was razed in the 1960s.

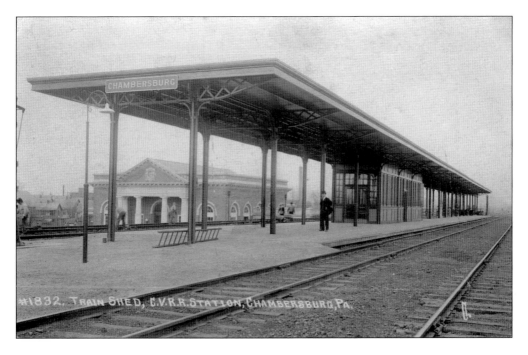

#1832. TRAIN SHED, C.V.R.R. STATION, CHAMBERSBURG, PA.

Before the advent of cars, the usual mode of travel was by horse and buggy. This bucolic view is of Mt. Parnell, the most prominent knob in Franklin County. It was named for Edward Parnell, who built a cabin there, perhaps as early as the 1730s, when he considered the area around Lemasters "overrun with too many Welsh settlers" for his liking.

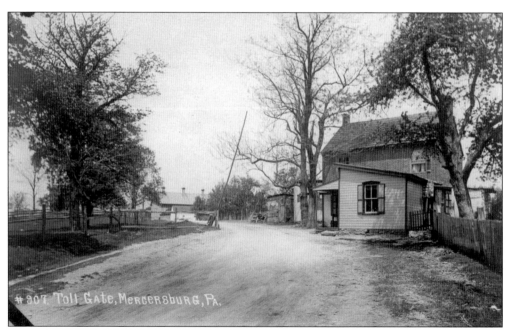

The tollhouse stood on the north side of Mercersburg along Route 16, which was part of the Baltimore and Pittsburgh Turnpike. Tollgates, sometimes called "pikes," would be raised or "turned" after the payment of a toll—hence the name "turnpike" for roads with such features.

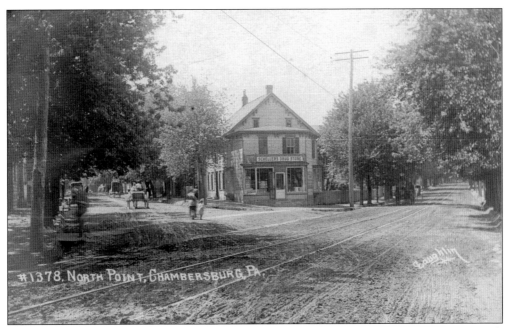

The north point in Chambersburg is where Second Street and Philadelphia Avenue intersect. Both the trolley lines and the still-common horse and buggy are in this image from the turn of the 20th century. Chambersburg's boundaries were often remembered by this rhyme: Point Lookout; Point Look-in, Point No-Point, and Point Again.

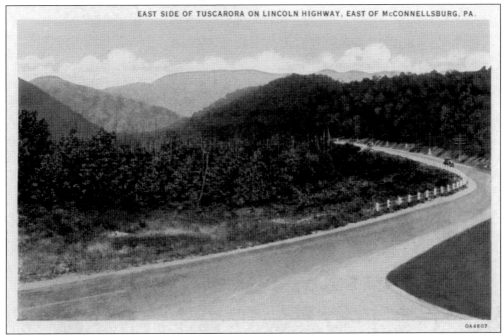

This early view of the Lincoln Highway is looking toward the beautiful Tuscarora Mountains, which bound the valley on the west. Before 1926 and the creation of the national highway system, the Lincoln Highway was "signed" with 18-by-12-inch porcelain enamel signs. In the 1920s, the boy scouts installed concrete mileposts bearing a bronze medallion of Abraham Lincoln.

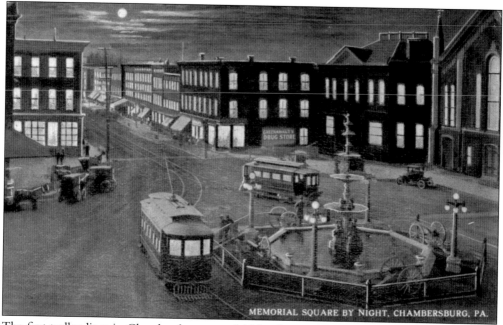

MEMORIAL SQUARE BY NIGHT, CHAMBERSBURG, PA.

The first trolley lines in Chambersburg were laid by the Chambersburg and Gettysburg Electric Railway Company in 1900. No less than 100 laborers were imported from Philadelphia during the first year of construction, and local laborers were used after that. In 1902, the finished trolley ran its first car from Memorial Square south on Main Street to Derbyshire Street, then to Queen Street, and finally back to the Square. A few years later, when lines were added in the western part of town, one problem existed; the trolley company did not have a right-of-way across the Western Maryland railroad tracks. The problem was solved by having one trolley car drive from the square to a point just east of the railroad tracks where the passengers would have to dismount and cross the tracks on foot; they would then board another trolley to complete their journey. (Courtesy of Kris Greenawalt.)

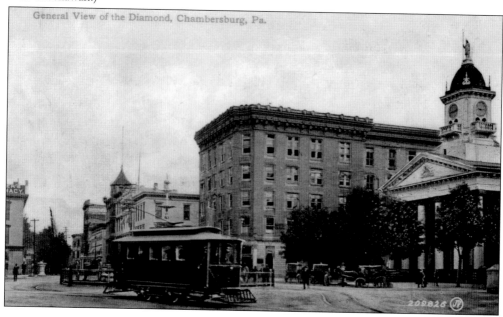

General View of the Diamond, Chambersburg, Pa.

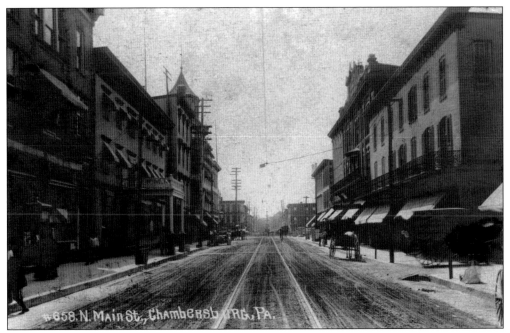

Almost all modes of transportation are represented in this photograph looking north on Main Street in Chambersburg—the horse and buggy, automobiles, tracks for the trolley, foot traffic, and a bicyclist in the center of the street. The building on the left with pillars is the Rosedale Opera House.

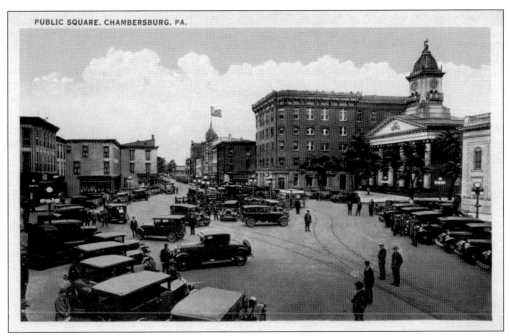

Early automobiles are lined up in Memorial Square (as it was then called) in Chambersburg in this photograph from the 1930s. It might have been an early automobile show or exhibit.

On a Saturday afternoon in September 1911, the first air flight over Chambersburg took place, starting from a field in the Norland area, north of town. The plane, flown by aviator Paul Peck of Washington, D.C., rose to approximately 150 feet for about five minutes before returning to earth. Peck complained of bad air and waited another hour before trying again. He rose 1,000 feet on his second attempt. Because it was dusk by then, the mechanics burned oil to show him where to land. It provided a great spectacle for the more than 5,000 people who came to witness this marvel.

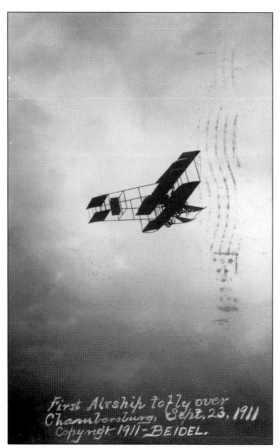

First Airship to fly over Chambersburg, Sept. 23, 1911 Copyright 1911 – BEIDEL.

Pennsylvania Railroad caboose No. 477951 was built in 1942 by the Pennsylvania Railroad and later purchased and restored by members of the Cumberland Valley Chapter of the National Railway Historic Society. It was moved to Norlo Park, Guilford Township, in 2002 and is currently on display there.

Six

PARKS, RECREATION, AND SPORTS

Nestled in the gap of the Tuscarora Mountain is Buchanan State Park. The park is an area of 18.5 acres, including picnic grounds. It is located near the birthplace of James Buchanan in Cove Gap. Surrounded by the Buchanan State Forest, this site is a great getaway for weekend picnics and hiking.

The Locked Antlers Hunting Club on South Mountain near Caledonia was started by a group of men who had found the skeletons of two male deer that had apparently died of starvation after their antlers had become locked. The club was organized in November 1890 and adopted a constitution and bylaws in December 1921. Notice the raccoon hanging alongside the deer in the 1908 card below.

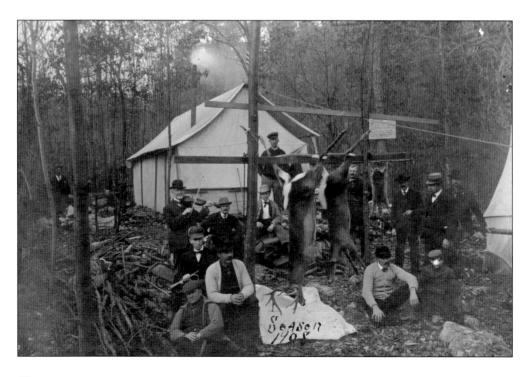

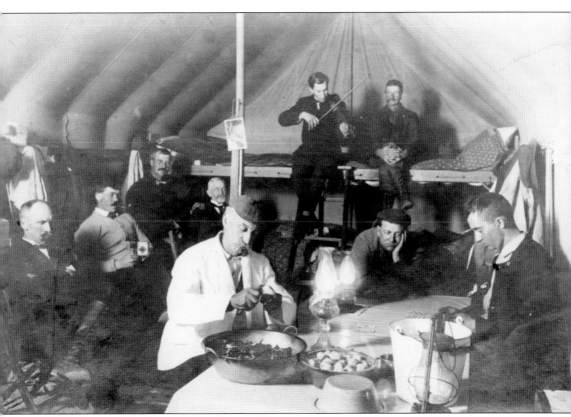

While someone is providing music at the hunting club, "Tommy," the cook, is making his famous potpie dinner after a day of hunting for "Rufus" (the hunters' jocular nickname for their deer quarry). The wives were invited to the potpie dinner, weather permitting, as was the state game commissioner, who claimed this was the second-best-equipped hunting camp in the state.

The back of this card reads, "Old Caledonia Springs Hotel, ruins of foundation, M.L. Dock 1897." About three miles east of the village of South Mountain stood the Caledonia Springs Hotel, opened prior to the Civil War by an association of local businessmen. It became popular as a summer resort with people from Baltimore but burned in late December 1862. Newspaper records suggest that it might already have been closed because of the war, as furniture had been previously removed and sold at auction in Chambersburg.

This scenic view is of the Ramble at Caledonia Park, which today is Route 233. The lake on the left runs under the bridge and forms a waterfall when it reaches the lower end of the park near Route 30. The lake is still a favorite fishing spot.

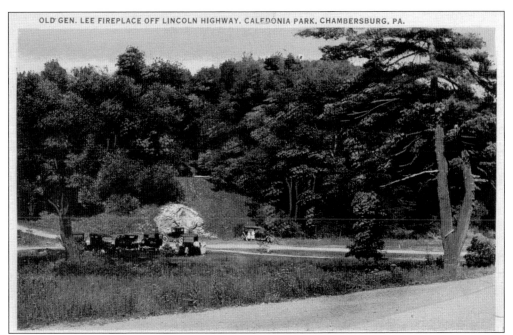

The Old General Lee Fireplace was at the entrance to the park. Today there is a monument there dedicated to Thaddeus Stevens, brought about, for the most part, by the intercession of Mira Lloyd Dock. The monument has a casting that bears the imprint of Thomas Warren's hands and the year 1837. Warren was a teamster for Stevens, and the large metal plate was cast at the old Maria Furnace in Fairfield, Adams County.

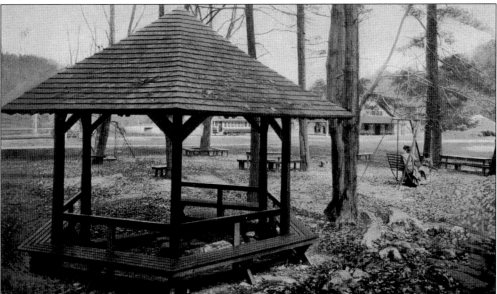

The original spring at Caledonia Park is shown in this postcard. The Chambersburg and Gettysburg Electric Railway Company built amusement rides and a dance pavilion to entice people to use their trolley line. The tracks ran on the south side of Route 30 from Chambersburg to Fayetteville. From Fayetteville to Caledonia, the tracks ran on the north side of Route 30. Passengers had to use three trolley cars and walk across two sets of railroad tracks to get from Caledonia to Chambersburg.

This view of the tall evergreens at Caledonia Park shows where Sunday school is held in the summer months. Called Sunday School in the Pines, it is a wonderfully serene place.

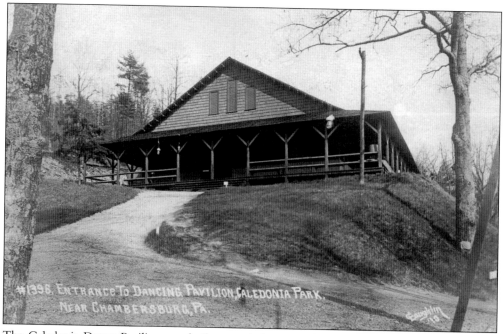

The Caledonia Dance Pavilion was built around the turn of the 20th century and was a major feature in the park. The trolley brought people from Chambersburg and Shippensburg to the park for 25¢. In 1951, it was converted to a playhouse, and summer theater began in our area.

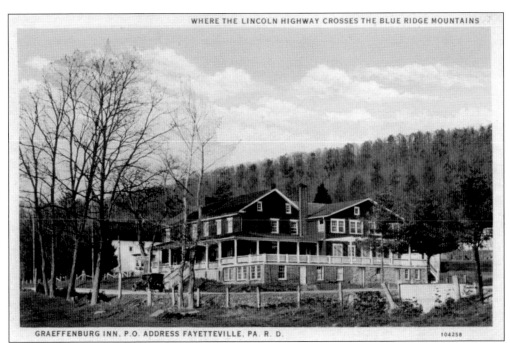

GRAEFFENBURG INN, P.O. ADDRESS FAYETTEVILLE, PA. R. D. 104258

The Graeffenburg Inn stood just east of Caledonia Park, "Where the Lincoln Highway Crosses the Blue Ridge Mountains," as the postcard reads. It was supposedly named for an Austrian village where a well-known spa was located. The county line between Adams and Franklin ran directly through the center of the inn, so that when the tax collectors came, the owner told Adams County that he only sold in Franklin County and Franklin County that he only sold in Adams County. This resort was a popular place, offering golfing, fishing, a bathing pool, tennis courts, and saddle horses. It was burned by an arsonist in 1980.

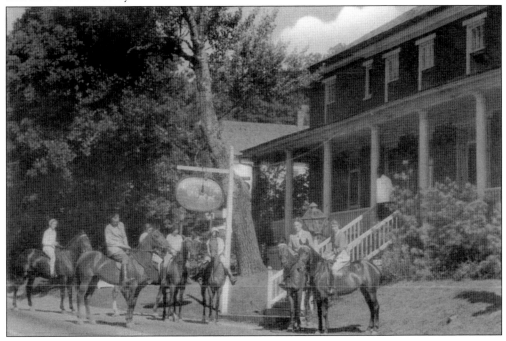

A favorite haunt in the area is the Totem Pole Playhouse, which opened in 1951 but was taken over by Bill Putch in 1954. The original building burned in 1969, and a new summer theater was built in 1970. This postcard shows the opening of the new theater with Jean Stapleton, wife of Putch, featured in *Hello Dolly*.

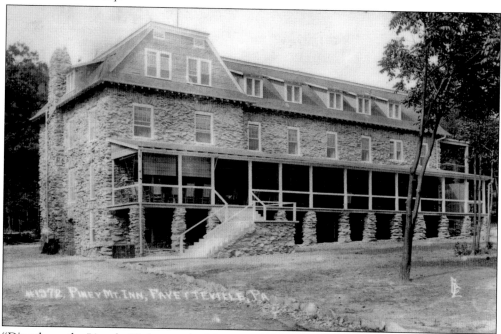

"Directly on the Lincoln Highway—the Main Street of America," Piney Mountain Inn was located halfway between Chambersburg and Gettysburg and offered "manifold attractions" designed for rest and relaxation in the mountains of southeastern Pennsylvania. The scent of the pine forests surrounding the inn suggested its name. Today, it functions as The Village of Laurel Run, a nursing facility.

Under the pines and a few hundred feet from the inn, there was a private swimming pool filled with cold but crystal-clear mountain spring water. It was for the exclusive use of the inn's guests. There were also facilities for tennis, badminton, shuffleboard, croquet, quoits, and table tennis.

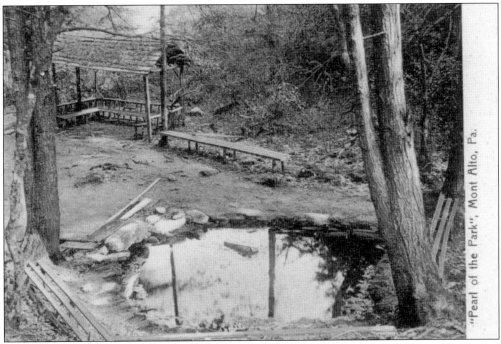

The Mont Alto Park was the oldest resort and recreation park in Franklin County. The "Pearl of the Park" was at the end of a pathway lined with laurel and rhododendron where a cool, small spring awaited visitors. It was named Pearl by visitors who were printers and were reminded of the smallest typeface then in use, which was called "pearl." The spring still retains the name.

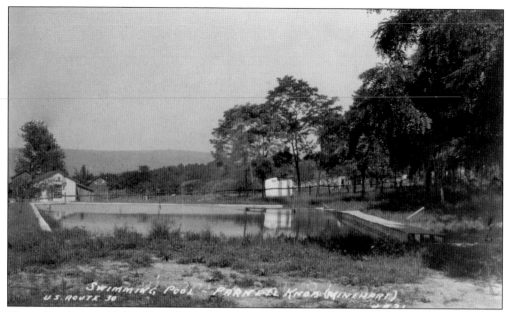

The swimming pool below Parnell Knob was located along Route 30 (the Lincoln Highway) west of St. Thomas. In 1918, T.Z. Minehart developed a community called Parnell Hills containing a number of small cottages and a mountain home for himself at the foot of Mt. Parnell. He was a well-known attorney in Franklin County and helped to organize the Orrstown Bank. He later established a museum containing the extensive collection of historical items garnered throughout his life.

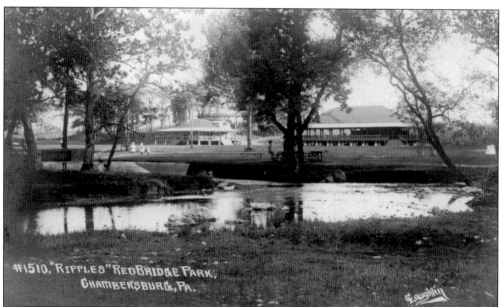

Since the owners of the Chambersburg, Greencastle, and Waynesboro Trolley Company were so successful with their transportation service, it was only a matter of time before they expanded to a different part of the county. Their next venture was Red Bridge Park—much closer to the town of Chambersburg. It included a merry-go-round, dance hall, restaurant, swimming pool, and other amusements to entertain families on weekends.

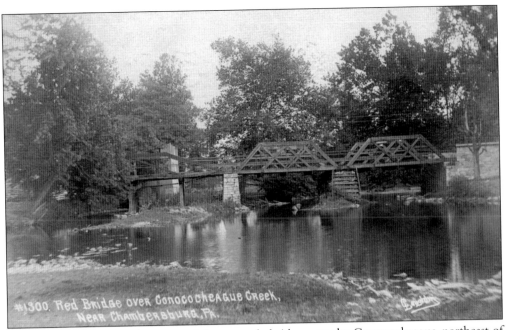

In 1913, work was started on a metal frame trestle bridge over the Conococheague, northeast of Chambersburg, and new track was laid to the northeast so that residents of Shippensburg would also be able to come to the park by trolley. The reddish color on the new trestle gave the park its name, Red Bridge Park.

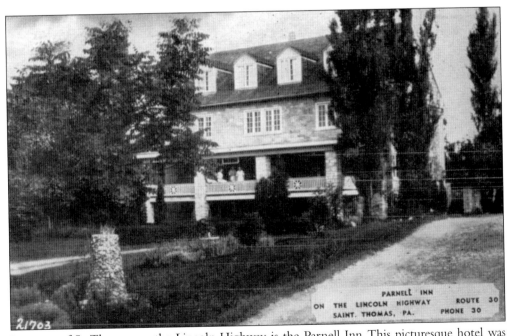

Just west of St. Thomas on the Lincoln Highway is the Parnell Inn. This picturesque hotel was originally a mill built by the Campbell family around 1832. It had also functioned as a tavern, and it was modified to become the American Legion at the end of World War II.

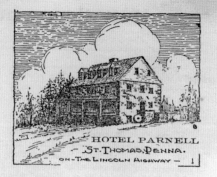
This old advertisement for the Hotel Parnell in St. Thomas shows the rates. At that time, it was operated by Mr. and Mrs. Chester Payne. On the opposite side of the card are references to stories and legends from the early days of the area—tales of Indians crawling through the high fields and also of the forty-niners who stopped here to replenish their supplies on their way to the west coast.

AMUSEMENT SECTION, PEN-MAR, PA. 90811

In the late 1870s, Pen Mar became known as a wonderful amusement park. There was a carrousel, a photographer's studio, a miniature train called the Little Wabash, a Ferris wheel, a penny arcade, a roller coaster, a movie theater, and an observatory or lookout north of the dancing pavilion from which you could see miles of the valley below. The lookout and dancing pavilion are still extant and provide a marvelous way to while away a Sunday afternoon, listening or dancing to music from the big band era while enjoying the atmosphere and the cool mountain air.

Look-Out at Pen Mar Park, Pa.

In these two images from the resort area are a walking path beside the train that brought visitors to Pen Mar, above, and the passenger station, below. To the right of the passenger station is the path up the hill to the overlook and dancing pavilion. Today, one marker by the overlook indicates where Lee retreated from Gettysburg in July 1863, and the other marker shows a map of the valley below.

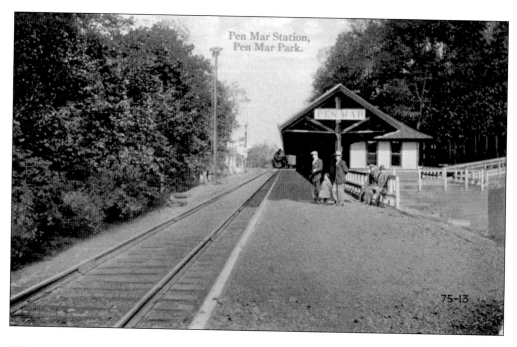

High Rock, Altitude 2,000 Feet, Pen Mar, Pa.

Beyond the Pen Mar Amusement Park were two towers, High Rock and Quirauk (Indian for blue mountain), built in the 1870s and 1880s, respectively. On a clear day, one could see the Shenandoah and Potomac Rivers and the Allegheny Mountains. It was said that with binoculars one could read the town clock in Chambersburg 24 miles away.

Ragged Edge, near Pen Mar Park.

75-10

Lake Royer, a man-made lake built in the 1890s by the Royer family, flows into Falls Creek, the mountain stream near Pen Mar, above. The Royer family had an ice plant at what is today Fort Richie on the border of Pennsylvania and Maryland. The fort was started as a National Guard Camp in the 1920s and later became Camp Ritchie (named after Maryland governor Ritchie) during World War II. In the 1950s, it became Fort Richie when Site R, an underground support center for the Pentagon, was built.

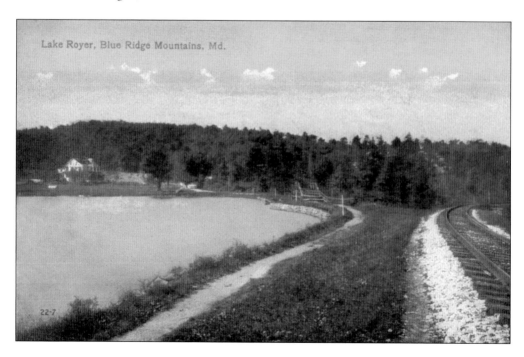

Lake Royer, Blue Ridge Mountains, Md.

22-7

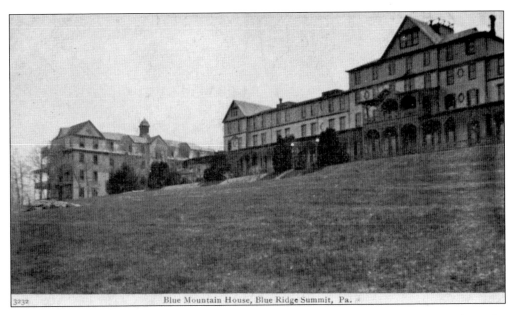

Blue Mountain House, Blue Ridge Summit, Pa.

This popular vacation spot was one of the resorts in the Blue Ridge Mountains along the Pennsylvania-Maryland border. The Blue Mountain House was built in 1883 and catered to the wealthy of Baltimore and Washington who traveled via the Western Maryland Railway up the steep grade to the summit. This was the high-society era—formal balls on Saturday night with ladies in evening gowns and gentlemen in tuxedos dancing to the music of an orchestra. The dining room, where guests enjoyed fresh, local fare, could seat 500 people, and tables were luxuriously set with linens and silver. Some notable guests were Presidents Wilson and Cleveland, and Gen. Ulysses Grant's daughter Nelly. The fire that destroyed the hotel in 1913 was caused by a gas jet igniting the draperies.

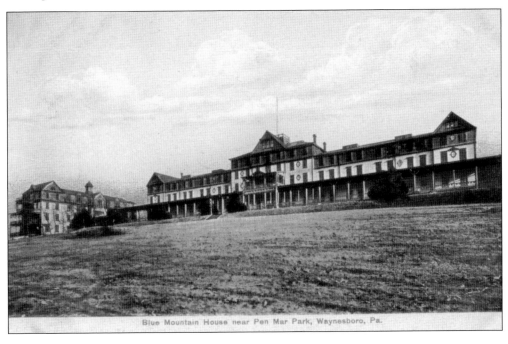

Blue Mountain House near Pen Mar Park, Waynesboro, Pa.

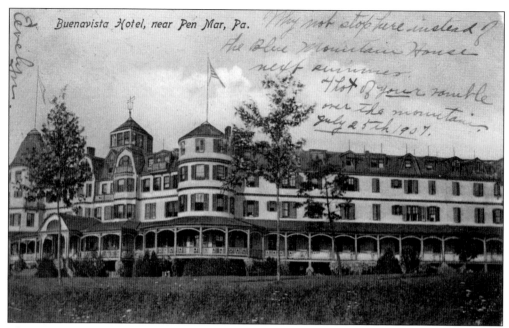

Buenavista Hotel, near Pen Mar, Pa.

Why not stop here instead of the Blue Mountain House next summer. Hot of your ramble over the mountain. July 25th 1907.

The greeting on this card attests to the rivalry between the two hotels—"Why not stop here instead of the Blue Mountain House next summer?" Built in the 1890s, the Buena Vista was the newer of the two and was to be grand, attract the best clientele, and be secluded from the crowds near Blue Mountain House and Pen Mar Park. It was completely self-sufficient and even had a printing press to publish its own brochures. The hotel was built in the Renaissance style and was four stories high. It closed its doors in 1931 and burned down in 1967.

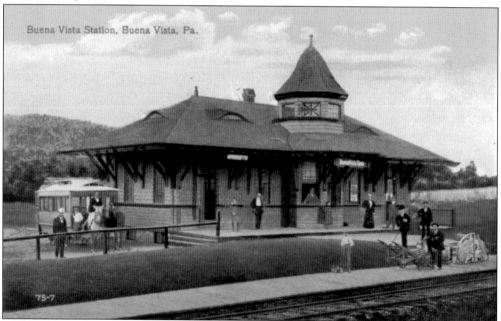

Buena Vista Station, Buena Vista, Pa.

The Buena Vista Station was built at the expense of the Buena Vista Hotel Company. As can be seen from the postcard, passengers enjoyed the ride to and from the station in a horse-drawn carriage, the horses outfitted with jingling bells to further delight the guests.

The Clermont Hotel on Charmian Road opened in 1864 with a spectacular view of the valley looking toward Gettysburg. Famous guests have included Pres. Ulysses Grant and Gen. Robert E. Lee, who was said to have rested under a large chestnut tree there. On July 4 and 5, 1863, as the 17-mile-long Confederate wagon train made its painful retreat from Gettysburg, it encountered Union troops along this road and the Battle of Monterey Pass ensued.

CHURCH OF TRANSFIGURATION, BLUE RIDGE SUMMIT, PA.

This church dates from the late 1800s, when summer visitors to the Blue Ridge area wanted a church in the Episcopal tradition. The exterior stone was quarried locally, and the interior contains an organ that is over 100 years old. This architectural gem no longer looks as it did in 1935, the year this postcard was mailed.

115

TENNIS COURT AND GOLF LINKS, MONTEREY COUNTRY CLUB, MONTEREY, PA.

Monterey Country Club is part of the Monterey Inn complex, which was established before the Civil War near the intersection of old Route 16 and Monterey Lane. An annex to the inn called Square Cottage was the birthplace of Bessie Wallis Warfield, for whom King Edward VIII gave up his throne. Presidents Wilson, Coolidge, and Eisenhower have played the famous golf course, which was built before 1885 and is one of the 10 oldest courses in the United States.

Glen-Afton Spring at Pen Mar is only a short walk from the park and became an enticing place for those individuals who enjoyed its fresh mountain water. The Western Maryland Railroad pumped water from the spring to a 20,000-gallon holding tank at the end of the park, from which it was dispersed to satisfy the many requirements of the park.

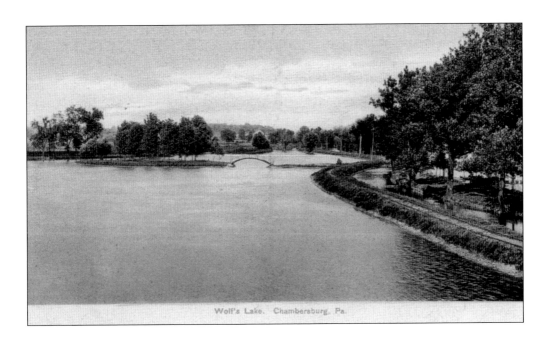

Wolf's Lake. Chambersburg. Pa.

In 1889, Augustus Wolf built a resort adjacent to his business complex in the northern end of Chambersburg. Costing between $35,000 and $45,000, its central attraction was Wolf Lake, half a mile long with an island approached by an arched bridge.

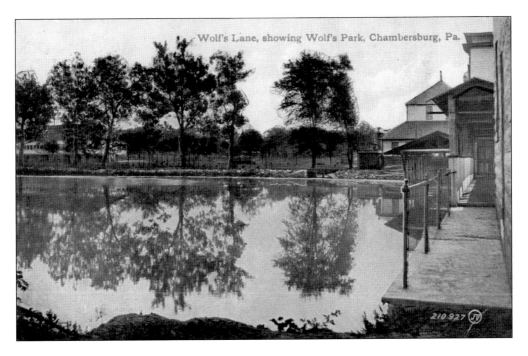

Wolf's Lane, showing Wolf's Park, Chambersburg, Pa.

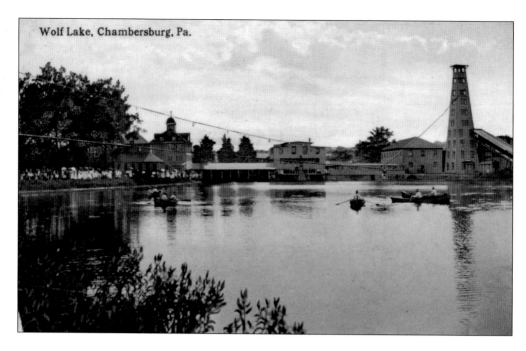

Wolf Lake, Chambersburg, Pa.

Wolf Lake was designed for both boating and swimming. Buildings included a bathhouse with hot and cold water, a bowling alley, a ballroom known as Dreamland, a dining room, and a pavilion. There was a viewing tower that contained 10 rooms for rent. Wolf manufactured his own light and power for the lake and park, and at night thousands of electric lights on the tower and boathouse created a veritable fairyland throughout the park. Part of the park incorporated a ball field, later renamed Henninger Field, where the Chambersburg Maroons of the Blue Ridge League played. Many senior citizens can remember what a wonderful place it was and lament its demise.

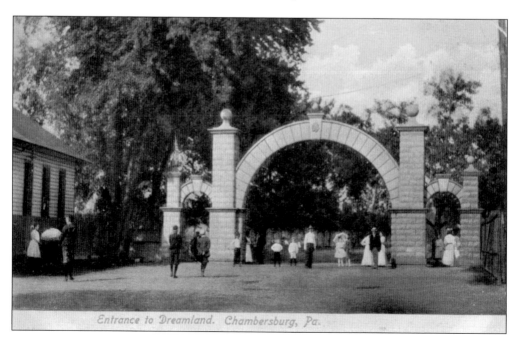

Entrance to Dreamland. Chambersburg, Pa.

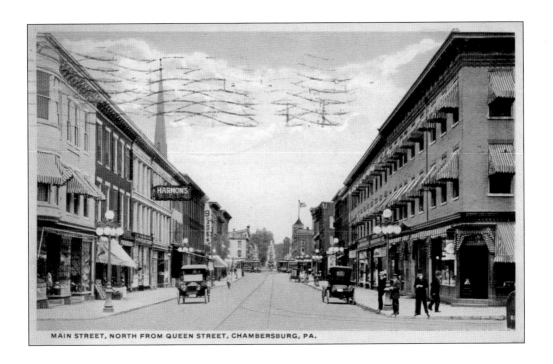

MAIN STREET, NORTH FROM QUEEN STREET, CHAMBERSBURG, PA.

These two views of Chambersburg, looking north from the corner of Main and Queen Streets, show that in 1912 and 1919 (the postmark dates on the back of the cards) Harmon's Furniture Store was located in the same space that the Capitol Theatre occupies today. The theater was built in 1926 by the Hafer Construction Company.

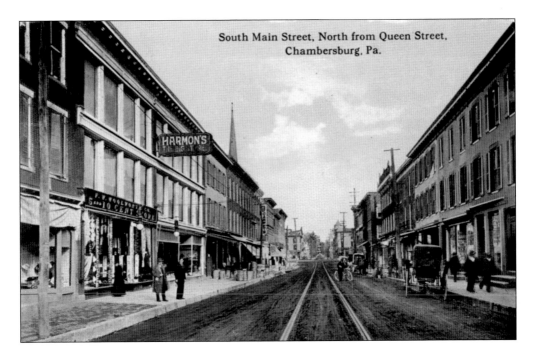

South Main Street, North from Queen Street, Chambersburg, Pa.

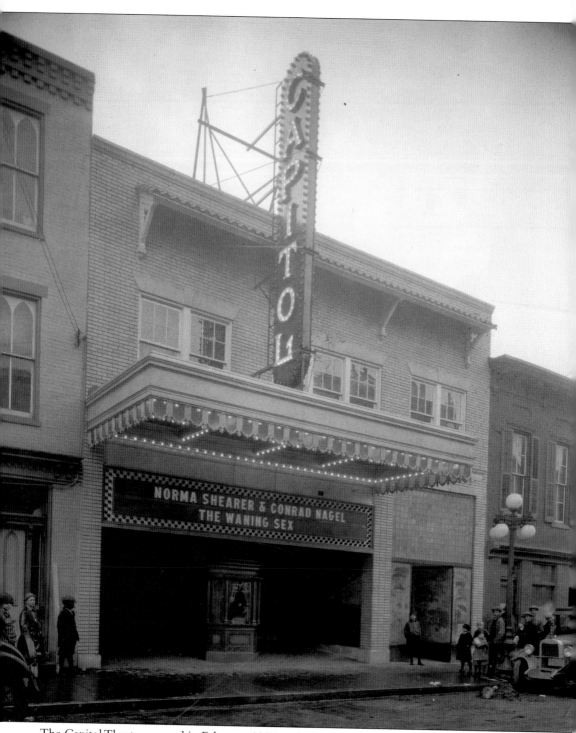

The Capitol Theatre opened in February 1927 with a silent film, which supposedly has been lost. The title was *The Waning Sex* and it starred Norma Shearer and Conrad Nagel. Shearer played a criminal lawyer whose gender was resented by Nagel's character. She wins acquittal for a man-chasing widow and then defeats her in romancing Nagel's character.

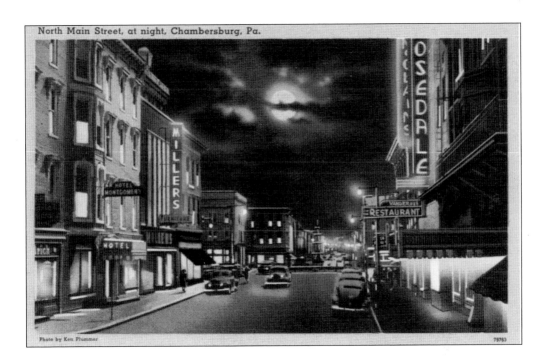

North Main Street, at night, Chambersburg, Pa.

Photo by Ken Plummer 79763

The nighttime scene above highlights the heart of Chambersburg. The Rosedale Theater was on the site originally occupied by the Rosedale Seminary for Young Girls (before the burning of Chambersburg). The seminary had been run by the Misses Eunicia, Mary, and Elizabeth Pineo. After the 1864 fire, the Rosedale Opera House was built there. The opera house was used for many events and occasions, including the suffragettes' gathering in 1914. Its final role was as a movie theater; it was razed in 1961.

ROSEDALE OPERA HOUSE.

MUSICAL EXTRAVAGANZA.

THE GNOME KING.

THURSDAY, JAN. 31, 1889.

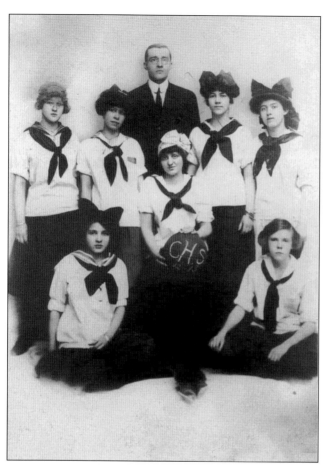

Young women from the Chambersburg High School played on a basketball team from 1912 to 1913. In the image at left, the girls are posing on a bearskin rug. Within the next two years, fashion will have changed dramatically and there will be no hats or bows in their hair.

The trinity of spirit, mind, and body—athleticism—was highly honored at Mercersburg Academy. In 1905, academy boys beat the leading private school, Exeter, in baseball; in 1906, they won 14 out of 15 games against schools such as Princeton, Franklin and Marshall, Exeter, and the Carlisle Indian School. This photograph is from 1907.

#601. BASE BALL GAME OF JUNE 3, 07.
ACADEMY and CARLISLE INDIANS, MERCERSBURG, PA.

These photographs of the baseball team of 1910 and the football team of 1909 from Chambersburg include some very serious-looking young men. They look determined to win. Obviously, the same man was coach for both teams. No high school yearbooks were published in those days, so one can only hope that they had a good season.

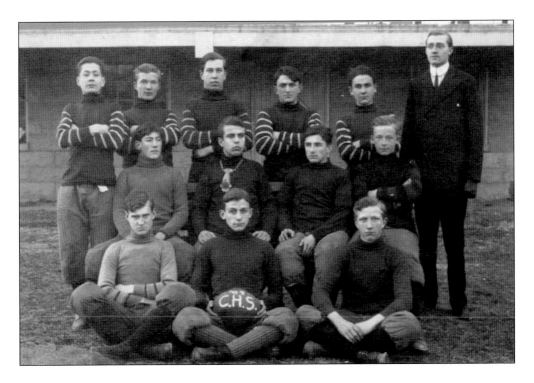

The Chambersburg Athletic Association (CAA) baseball team won the Cumberland Valley championship in 1913. That year, the groundwork was laid for the formation of the Blue Ridge League, with the CAA listed as an amateur group. The next year, some of the players received salaries, and the team entered the semipro ranks.

Augustus "Gus" Dorner was born and lived his entire life in Chambersburg, except for the 11 years when he was playing professional baseball. He left home for the first time in 1901 at the age of 24, played as a pitcher in the minors for a few years, and in 1903, joined the Cleveland team in the American League. He was then traded to Columbus, Ohio, where he helped win the pennant in 1905. In 1906, he was with Cincinnati; then Boston in 1907 and 1908. After several more years of being traded, he decided to retire and come back to Chambersburg, where he maintained an active interest in the Twilight League until his death in 1956.

Richard McFadden was an inspirational athlete who excelled in baseball, basketball, track, and soccer. A star performer at Lemasters High School, he later went to Mercersburg Academy where he won the Williams Cup, awarded to athletes who produced the highest number of points in six events—120 hurdles, high jump, long jump, shot put, and javelin. He was offered a professional baseball contract by the New York Yankees in 1943 but was drafted by the Army before signing. He was killed at Alsdorf, Germany, in November 1944, just before the breakthrough in the Battle of the Bulge. He was awarded the Purple Heart posthumously, and in 1990, he was inducted into the Pennsylvania Sports Hall of Fame.

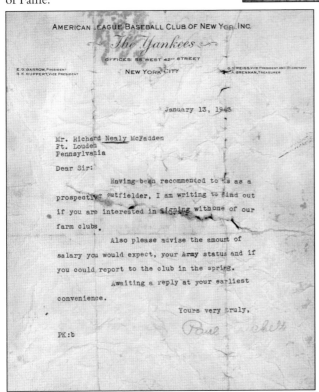

Nelson "Nellie" Fox was born in St. Thomas (Franklin County) in 1927. He was already a bat boy for the town team when he was six years old. At 16, his father took him to the spring training camp of the Philadelphia Athletics at Frederick, Maryland. Manager Connie Mack signed him up immediately. He played on 13 American League All Star teams and was named the Most Valuable Player in the American League in 1959. He also won the Golden Glove Award as outstanding second-base fielder from 1957 through 1960. His greatest success was with the Chicago White Sox. (Left, courtesy of Jean Gonder.)

THE HOLLER GUY

Nellie Fox

This holler guy who we are follering,
What does he holler when he's hollering?
You can hear him clean to hell and gone,
C'mon there baby, c'mon, c'mon!

Or he will change his holler, maybe,
To Let's go, baby, baby, baby!
He uses a plug of tobacco per game,
And has never lost or swallowed same.
Nellie Fox so lives to play
That every day's a hollerday.

By Ogden Nash,
For Life Magazine,
September 5, 1955

Ogden Nash
(Life Magazine, Sept. 5, 1955)

In 1952, Nellie's followers from the Chambersburg area took a trip to Washington, D.C., to attend one of his games. Nellie, center, is sporting a fake beard, but most of the men are growing real ones for the sesquicentennial in Chambersburg. The "Brothers of the Brush" beard contest was a feature of the celebration. (Courtesy of Kris Greenawalt.)

www.arcadiapublishing.com

Discover books about the town where you grew up, the cities where your friends and families live, the town where your parents met, or even that retirement spot you've been dreaming about. Our Web site provides history lovers with exclusive deals, advanced notification about new titles, e-mail alerts of author events, and much more.

Find Your Place in History.